# EDINBURGH AT WORK

C000136422

## MALCOLM FIFE

AMBERLEY

*In memory of Helen Zienkiewicz*

First published 2018

Amberley Publishing
The Hill, Stroud
Gloucestershire, GL5 4EP

www.amberley-books.com

Copyright © Malcolm Fife, 2018

The right of Malcolm Fife to be identified as the
Author of this work has been asserted in accordance
with the Copyrights, Designs and Patents Act 1988.

ISBN 978 1 4456 7066 9 (print)
ISBN 978 1 4456 7067 6 (ebook)

British Library Cataloguing in Publication Data.
A catalogue record for this book is available
from the British Library.

Origination by Amberley Publishing.
Printed in the UK.

# CONTENTS

# INTRODUCTION

Edinburgh is the jewel in Scotland's crown. Its banks, businesses and financial companies are major contributors to the country's prosperity. The city's reputation not only attracts companies from across the United Kingdom but from many other parts of the world as well. Students of many nationalities study at its universities. Research at these institutions make Edinburgh the centre of many leading technological innovations particularly related to computing. Its world-famous international arts festival draws visitors from around the globe. This further contributes to its economy employing large numbers of people in the hotel and catering trade. For most of its history, however, Edinburgh consisted of little more than a few streets of wooden buildings nestled close to its castle for protection. It was within the town walls that markets were held and merchants resided. As the king and his court often stayed at the castle and later Holyrood Palace, this created employment for the craftsmen who turned out expensive clothing and goods for them. As money flowed into Edinburgh, it created a need for financial institutions accompanied by lawyers, providing the foundations for the city's present wealth. At the end of the eighteenth century, the city began expanding across the surrounding countryside engulfing many smaller settlements and villages. By the mid-twentieth century it was estimated that Edinburgh extended across an area 200 times the size of the medieval town. By the early twenty-first century, its boundaries extended from Newbridge in the west to the edge of Musselburgh in the east, and from Leith on the Firth of Forth to the Pentland Hills in the south. Its population in 2017 was around 500,000.

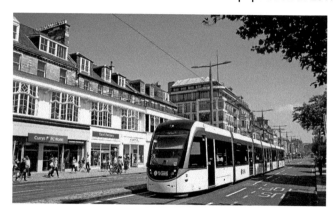

Princes Street in 2017. For much of the nineteenth and twentieth centuries it was at the heart of Edinburgh's business and commercial activities.

# THE ERA BEFORE 1500

Some of the earliest evidence of the existence of human habitation in Scotland comes from Cramond, on the edge of Edinburgh, where stone tools dating back to 8500 BC were discovered near the seashore – evidence of a prehistoric camp. These early inhabitants of Scotland lived by fishing and gathering shellfish. To supplement their diet, hazelnuts were gathered and then roasted. Once the resources in the locality of Cramond had become depleted, the hunter gatherers would have moved to a new location on a different part of the coast. As the numbers of people increased, some groups would have moved inland to exploit new sources of food.

Farming arrived in Scotland around 3800 BC, leading to a considerable change in how people lived and worked. Instead of a nomadic lifestyle, people now began to live in large permanent settlements. Forts were established on several of Edinburgh's hills. Their inhabitants would have spent their time tending livestock and growing wheat and barley. In parts of central Scotland forests were cleared and replaced with pasture and heath. Stone tools were supplanted by those made from bronze.

Almost all of the basics of life would have still been met by resources within a few miles of the hill forts. Even most of the metal tools were probably produced locally, as the fragments of moulds have been found in many settlements across Scotland. Their creation would have led to the rise in importance of specialised craftsmen, who likely had greater status than those who worked the fields. Not all Iron Age people were confined within the walls of hill forts. There were also many small farms interspersed between the woodlands and patches of boggy ground.

The arrival of the Romans in Scotland would have had relatively little impact on the day-to-day activities of most of the native population, who continued growing their crops and herding their cattle. The first towns in Britain, including London, were established by the Romans, but they were confined to England. The nearest equivalents in Scotland were the civilian settlements that grew up next to the walls of the Roman forts at the mouth of the River Almond at Cramond and at Inveresk, Musselburgh, whose occupants traded necessities with the garrisons. Not far away, Roman pottery has been discovered on the site of Edinburgh Castle where there was a hill fort at the time.

The hill forts that crowned the summits of the hills around Edinburgh began to be abandoned from the time of the Roman occupation. Eventually, only the fortification on the Castle Rock remained most likely due to the fact that it was easily accessible compared

with those on Arthur's Seat. It was also more easily defended, being located on an isolated rocky outcrop having commanding views across the surrounding landscape and the Firth of Forth. Ancient trackways probably passed close to it and later the Roman roads serving their forts at Cramond and Musselburgh. In time it would become one of the longest continually occupied sites of human habitation in Scotland and the nucleus for its capital city, Edinburgh.

Malcolm III had a royal residence on the Castle Rock between 1057 and 1093. Huddled beneath it on a narrow ridge was a small group of houses that in time became the city of Edinburgh. Queen Margaret, Malcolm III's wife, encouraged foreign merchants to come to Scotland with precious metal, ornaments and cloths of many colours. The population of Scotland then probably numbered several hundred thousand, almost all of whom lived on small farmsteads in the countryside.

In 1124, David I ascended to the throne of Scotland and introduced numerous far-sighted reforms that would transform a society whose ways had not changed much since the Iron Age. He had been brought up at the Anglo-Norman court of King Henry and had been impressed by its administrative organisation as well as its high standard of living. Legislation was passed by David I and his successors that encouraged the creation and growth of towns, as well as promoting trade. Royal burghs were established, among the first being Edinburgh, Haddington and Linlithgow. These settlements were given the exclusive trading rights of their sheriffdoms. Goods for sale had to be sold at markets in the towns and a toll paid on them, which was collected on entry at the town gates. There were further charges to be paid for the hiring of stalls on market days – one halfpence if the booth was covered and one farthing if uncovered. Edinburgh, like other medieval towns, was very dependent on the produce of the surrounding countryside. Sheep and cattle would be driven to market here and slaughtered for their meat. Grain would also be brought from outlying areas and sold in the open-air markets.

David I also encouraged Catholic orders of monks from England and Continental Europe to settle in Scotland and replace the disorganised Celtic Church. The monks had an important role in many aspects of the life of the country outside religion. Holyrood Abbey was established about a mile to the east of Edinburgh Castle in 1128. Its Augustine canons were given numerous privileges, including a portion of the skins and lard from the cattle slaughtered for the royal household as well as mills on the Water of Leith and a salt works. The Royal High School, which has gone on to become one of the oldest schools in the world, started out as a seminary established by the monks in the twelfth century. In later centuries, Edinburgh would evolve to become a world renowned centre of education. The monks of Holyrood were also the first to exploit the springs from the aquifer that lay underneath them to brew beer. In time it would become one of Edinburgh's most important industries.

Leith has been Edinburgh's seaport since at least the twelfth century. At that time, the two towns were separated by open countryside. The harbour was located at the mouth of the Water of Leith where it flowed into the Firth of Forth. Ships unloaded their cargoes onto wooden quays on the banks of the river. It is thought that wine was imported here in the twelfth century for consumption by the abbot and canons residing in Holyrood Abbey. There was little overseas trade through Leith until the sacking of Berwick-upon-Tweed, then Scotland's main port, by the English in 1296. In 1329, a charter, which would last for the next 700 years, was drawn up by Robert Bruce to give the Corporation of Edinburgh control of the port of Leith. At that time it exported 170 tonnes of wool a year. Around fifty years later, it was handling half of Scotland's export of this commodity, but even in its busiest years Leith handled only around thirty ships involved in foreign trade, most of which were not of great size.

It is perhaps due only to the fact that Edinburgh Castle was situated on an almost impregnable site on a rock that Scotland's most important city evolved here and not a couple of miles away on the shore of the Firth of Forth. Consideration was at one time given by at least one king to moving the capital to Leith. Edinburgh Castle itself was far more than just being a royal residence. During the reign of Robert II (1371–90) bows, crossbows and siege engines were made in its workshops.

The fifteenth century witnessed several major developments in the economy of Edinburgh. In 1424 the first inns appeared in the town. Many of the early inns were below street level and some had no windows. To encourage their patronage, travellers were forbidden by law to stay with friends. Householders could be fined 40 shillings – a very considerable sum at the time – if they infringed this regulation. The inns had to provide stabling free of charge but the traveller paid for the corn and hay.

Although the kings of Scotland spent much of their time at Edinburgh Castle, Perth was the base of government and was regarded as Scotland's capital city. This all changed when James I was assassinated there. Royalty then abandoned it in favour of Edinburgh and by 1437 it had displaced Perth as the capital city. Nobles now resided in the city or in numerous castles and tower houses in the surrounding countryside. Their presence created a demand for luxury goods, many of which were imported from the Continent through Leith. Wine was the main import sourced from France, but other goods imported included saddles and suits of armour from Flanders. In 1430, Sir Robert Logan invited monks of the Order of St Anthony to settle in Leith. They supervised the import of wine to the Edinburgh merchants and in turn received a portion of every cargo of this type that arrived at the harbour.

Edinburgh's fortunes were further boosted when James III was held prisoner by his own nobles in the castle. The Duke of Albany rescued him with the help of burgesses of the town. James never forgot his debt to them. In 1479, he rewarded them with a charter that extended their trading privileges.

At that time all aspects of work were heavily regulated. A person could not set up a business without being a member of the relevant guild or 'incorporation', as they were known in Edinburgh. Weavers and hatmakers were required to undertake a five-year apprenticeship and in some other trades it was as long as seven. To qualify as a craftsman there was an assessment at the end of the training by a panel of experts. If the apprentice failed he could spend the rest of his life as an employee with no hope of branching out to form his own business. Occasionally, women undertook apprenticeships but they were not allowed to become fully fledged members of the trade. Some with the means to do so established their own businesses and employed their own workmen.

Apprentices that qualified paid their fees to become freemen and could then start a workshop of their own. Their work could be inspected at any time to ensure that it did not discredit their profession. Masons and wrights, who were often involved in the construction of new buildings, were subject to particularly stringent checks. Every stage of their work was inspected by two expert masons or wrights. At that time, like most other craftsmen, they worked long hours. Masons working on St Giles' Cathedral began at five in the morning in summer and continued until seven at night. They stopped for two hours at eleven o'clock and had a further two half-hour breaks. Butchers were subjected to a daily check to ensure that they did not sell meat from a diseased animal. If they were caught doing this, they could be punished by being banished from Edinburgh. If damaged sheepskins were sold by skinners, they could be subject to a fine.

There was a constant demand for high-quality clothing from the more affluent residents. Although some items were imported, master weavers made garments on their own looms.

A seven-year apprenticeship was required before they were thought skilled enough to turn out high-quality clothing. The same applied to those who made market shoes. There were strict regulations as to what clothing people could wear in the fifteenth century. Only lords and knights were allowed to wear silk and furs. People had to wear grey and white on working days and only on holy days were they allowed light blue, green and red clothes.

The guild of Hammermen covered a wide range of craftsmen, including armourers, blacksmiths, cutlers and goldsmiths. Three experts inspected their work on Saturday mornings to ensure the items on sale were of good quality. They were protected from competition as no one was allowed to sell imported goods that the Hammermen of Edinburgh also produced. The only exception to this regulation was for a period of four hours on market day.

Up until the fifteenth century shops did not exist. All goods were sold in open markets in the High Street around the market cross. In 1477, the town council allotted particular sites for the sale of various products. There were no less than fifteen markets. Cottons and linens were to be sold in the Lawnmarket, dairy produce and wool near the Upper Bow. A charter drawn up in 1477 decreed that cattle could not be brought into the burgh. Markets for them had to be held in the vicinity of King's Stables Road and the Grassmarket. Some traders began

The site of the Roman fort at Cramond. It was first established around AD 140 during the building of the Antonine Wall. A civilian settlement grew up next to it, where items such as pottery were made.

to set up booths around St Giles and in time they took on a permanent form as luckenbooths (derived from 'locking booth'), meaning a small lockable shop. The first was constructed in 1440 and was housed in the ground floor of a two-storey building. Eventually there were seven similar enterprises, probably the first shops in Scotland.

In the fourteenth century, an English nobleman had described Edinburgh as 'a mean place' but by 1478 a fellow countryman said it was 'a most wealthy town'. Even so, it was still little more than a few streets of wooden buildings hugging the ridge that ran towards Holyrood Abbey. Leith at that time was an even smaller settlement with a few houses clustered around the wooden wharfs and warehouses. James I founded an important complex of buildings known as King's Wark on the ground between what is now Broad Wynd and Bernard Street. Its initial function was as an ordnance factory with storage space for artillery, and it would have been among the first industrial complexes in Scotland.

As well as providing a harbour for Edinburgh, the Water of Leith was its first power source. Mill wheels were driven by its waters to grind grain. Later there was competition for space on its banks by other industries that also wished to harness its power.

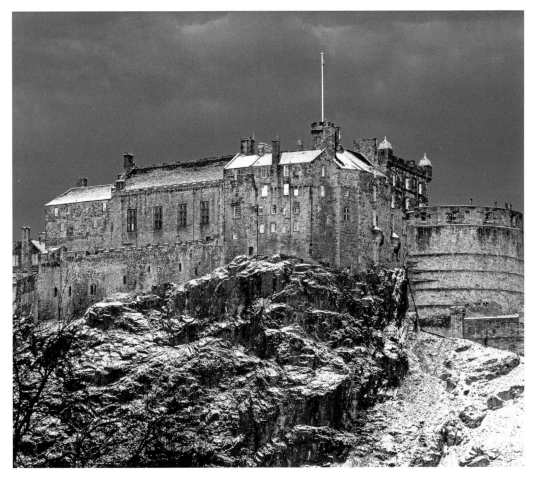

Edinburgh owes its existence to the Castle Rock, which could easily be defended. A small settlement grew up in the shadow of its castle, which was frequented by the kings and queens of Scotland. Their wealth helped attract merchants and tradesmen to the town.

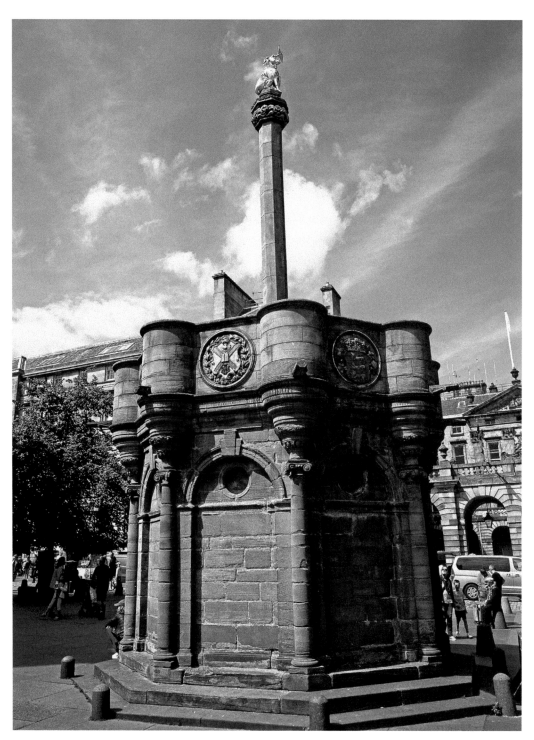

The Mercat Cross in the High Street. It served as a landmark for merchants and traders as to where they could sell their goods. The present Mercat Cross is a Victorian replica of the original medieval example, which stood a short distance to the east.

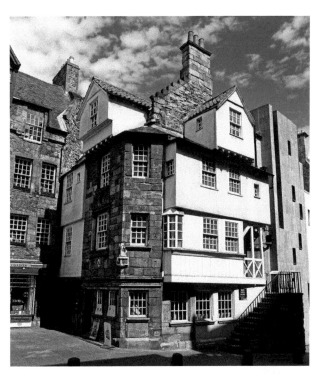

John Knox House in the Royal Mile. Although named after the famous Scottish religious reformer, it is thought he lived here only a short time. It dates back to the fifteenth century and was rebuilt by James Mossman, goldsmith to Mary Queen of Scots, who was executed in 1573 for supporting her. Around that time, many of the more prosperous residents began to build their homes out of stone instead of wood.

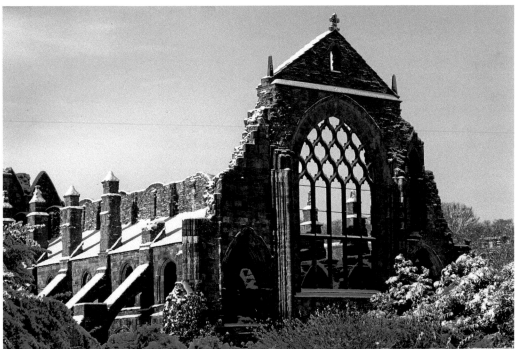

Holyrood Abbey was much more than just a place of prayer and contemplation. Its monks controlled large areas of agricultural land as well as early industrial enterprises such as watermills and salt pans. They also supplied assistance for the destitute and sick.

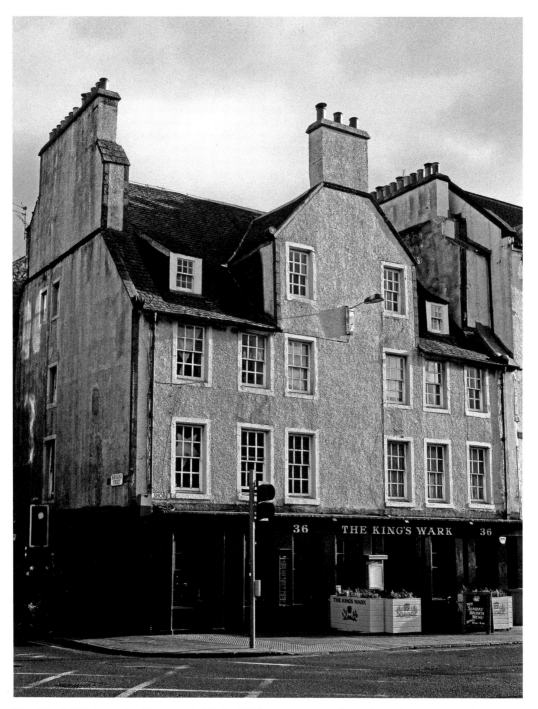

The King's Wark on the Shore at Leith. In 1434, an arsenal and royal residence was built at this location. Just over a century later the complex of buildings was destroyed by the English when they invaded Scotland in 1544. The present building, now a restaurant, dates from the early eighteenth century.

# THE SIXTEENTH AND SEVENTEENTH CENTURIES

I n 1500, Edinburgh had an estimated population of 12,000. Since the twelfth century there had been an abbey at Holyrood, which had played an important role in Scottish affairs. Parliaments and royal councils were held there and nobles would often stay in its guest house when visiting Edinburgh. There was limited room to expand the Royal Residence at Edinburgh Castle and at the beginning of the sixteenth century, James IV constructed a palace next to the abbey. This further enhanced Edinburgh's role as the power base of Scotland. Some of the rich and powerful built houses a short distance away in the Canongate. Others lived in castles and tower houses – said to have numbered over a hundred – in the neighbouring countryside. Money flowed into the pockets of the local merchants and craftsmen. By 1535 Edinburgh alone contributed to 40 per cent of Scotland's burgh taxation.

The long legacy of shipbuilding at Leith began with the construction of the *Margaret*, the port's first warship. It was ordered by James IV, who intended Scotland to have a powerful navy. The *Margaret* was launched in 1505. Needing deeper water for the building of larger vessels, James IV also established a shipyard a short distance to the west of Leith at Newhaven. It was from here that the *Great Michael*, the largest warship ever built in Scotland up until that time, was launched. It was 240 feet in length and had a crew of 300.

The first printing press arrived in the country from France in 1507 at the specific request of James IV, who wished to publish acts of Parliament, laws and the legends of Scottish saints. Androw Myllar, a resident of Edinburgh who had been taught the skills of printing at Rouen, started a publishing business in the Cowgate with Walter Chepman. In time, publishing would become one of Edinburgh's most important industries. An unexpected catalyst for the Scottish publishing industry was the Reformation and subsequent religious turmoil. The printed word was a powerful means of promoting the arguments of various causes as well as denouncing opponents. In 1552, an attempt was made to regulate what was printed and to guarantee the orthodoxy of any particular work. Failure to comply could lead to the confiscation of the publisher's assets as well as banishment.

By 1584 the number of printing presses in the city had grown to six. Printing created a demand for paper and the first paper mill in Scotland was established on the Water of Leith at Dalry with the assistance of German expertise.

Once night fell, Edinburgh residents could read and write only by candlelight, so the manufacture of candles was a flourishing craft that gave employment to many. Tallow and wax were the main constituents of candles but the stench of their manufacture meant that the

industry was regulated to the outskirts of the city. Like most other crafts of its time, it was governed by a host of medieval regulations. It was unlawful for a candle maker to employ an apprentice for less than four years or take the apprentice of a fellow craftsman without permission. Fines were imposed if candles were sold above their statute price. There were restrictions on the sale of tallow outside the city but a good deal of illicit candle making was carried on beyond the town wall.

With the abolition of the monasteries, brewing became a secular activity. Ales were brewed in houses or inns, often by women. The first steps to establish brewing on an industrial scale took place at the end of the sixteenth century. A society of brewers was formed in 1596 and a brewery began operating two years later. Water was taken from the Burgh Loch with the assistance of a windmill (at the site of what is now The Meadows) to brew beer. This activity was carried on in the vicinity of Bristo Port, the name being derived from 'brewer'. Within the town itself the wells had to be locked at night to prevent the water being used to make ale.

The development of Edinburgh received a serious setback during a series of English invasions often known as the 'Rough Wooing'. In 1544, Henry VIII ordered his army to 'put all to fire and sword, burn Edinburgh town ... putting man, women and child to fire and sword without exception where any resistance shall be made'. At that time most of the houses were made of wood and were burned to the ground. A French medieval chronicler a couple of centuries earlier had stated that the town could be rebuilt in three days after such assaults.

Merchants would have conducted much of their businesses in their homes and craftsmen often had their workshops in their attics. When Edinburgh was rebuilt many of the houses of the more affluent were built in stone. There were many experienced masons who had worked on Holyrood Palace as well as the numerous churches and monastic buildings.

Another invasion threatened in 1558. Burgh records relate that the merchants could offer 736 men for the defence of Edinburgh and the crafts 717. Of the latter, some 178 tailors volunteered along with 151 hammermen, 100 bakers, sixty-three skinners, forty-nine shoemakers, twenty goldsmiths and nine furriers and goldsmiths.

Towards the end of the sixteenth century, a significant step was taken to make the town a major centre of education after an earlier attempt had met with little success. The convent of Greyfriars, with the support of James I, had set up an educational seminary teaching divinity and philosophy, but even with the help of tutors from abroad it remained an obscure institution. A far more successful effort took place after the Reformation when the town council along with the Protestant clergy proposed that Edinburgh should have a college for the education of its youth. By this time Aberdeen, Glasgow and St Andrews already had their own universities. Land was acquired at Kirk o' Fields and the building of the college got underway in 1580. James IV drew up several charters that gave Edinburgh Town Council the power to appoint professors in various branches of learning, including divinity, law and medicine. In 1583, the new university opened its doors to eighty-four students. The course lasted four years with Greek and Roman classics being taught in the first year. Edinburgh in the sixteenth century was also beginning to become an important legal centre with the formation of the Court of Justice in 1537.

The abolition of the monasteries at the end of the sixteenth century resulted in an influx of tradesmen who once worked for them looking for work in Edinburgh. Another political event that had repercussions on the development of Edinburgh's economy was the Union of the Crowns in 1603. James VI and his court packed their bags and headed for London where he would rule over both England and Scotland. This had an impact on the craftsmen such as jewellers, who produced luxury goods, and merchants catering for the tastes of the rich and famous. Even more mundane activities such as printing did not go unscathed as there was less demand for administrative documents.

But Scotland still remained an independent country with its own parliament. Edinburgh became a city in the seventeenth century and the pace of economic change began to gather momentum. There was a boom in acquiring rural property throughout Scotland by Edinburgh merchants as collateral for lending money to nobles and lairds. In 1618, there were 475 merchants in the city with many of the wealthiest involved in this activity. They had properties extending the length and breadth of the country but most preferred to remain living in Edinburgh. This led to the flow of money into the city where there were numerous lawyers to deal with any legal issues that would arise from land disputes. Near the end of the seventeenth century, they made up 62 per cent of those employed in the professions of Edinburgh. A further 22 per cent was made up by doctors and surgeons. The merchants' role as moneylenders was superseded when the Bank of Scotland opened for business in 1696.

Although the monarch now resided in London, Charles II reconstructed the Palace of Holyrood House between 1671 and 1678 in the form visible today. Fireplaces were imported from Italy and glass from France. The plasterwork was undertaken by workmen from England and the Dutch artist de Witt was commissioned to paint the kings of Scotland for the picture gallery.

In the early seventeenth century, there were many complaints about the poor standard of workmanship of Edinburgh's craftsmen. These included sub-standard footwear but the shoemakers blamed the tanners for producing bad leather. Flemish cloth makers were encouraged to come to Edinburgh in an effort to improve standards. Instructors in tanning and other trades followed. By the end of the century, the situation had been improved. New crafts and industries also emerged around this time. In 1681, engravers began to work in the city and by 1720 'no other city of the Empire outside of London can present a record in the art of engraving at all approaching that of Edinburgh'.

Ten years later, the first maker of surgical instruments set up business. In the sixteenth century clocks began to be erected on public buildings. Initially clocks were imported, but by the seventeenth century they were being manufactured in Edinburgh. Paul Roumieu, the first watchmaker, set up business in the West Bow in 1677. His successors gained a reputation for high-quality timepieces.

Glassmaking began in Edinburgh and Leith around the middle of the century, using the plentiful supplies of sand and kelp, the latter producing potash when burned. There was a great demand for beer bottles and for drinking glasses for the wealthy. By 1720 there were around 120 glassblowers at Leith. Scottish alcoholic beverages had a reputation with visitors to the city of being of very poor quality. One of the first attempts to produce beer on a large scale was undertaken by a Mr Stansfield (an Englishman), who built a new brewery at Yardheads, Leith. Constructed around 1670, it was in its time the largest brewery in Scotland. Both Edinburgh and Leith were well placed to develop this industry, being close to the fertile farmland of East Lothian where large quantities of barley were grown. Barley was germinated and then dried to make malt for the mash. Coal for heating and boiling the mash was mined only a handful of miles away.

Tea became a favourite drink with ladies and began to be imported on a large scale. The first coffee house opened in 1663 in Parliament Close. From 1680 there was also an increasing demand for tobacco. Clay pipes featuring a military theme proved popular with the soldiers garrisoned in Edinburgh Castle. There were 134 tailors in 1636, by which time Edinburgh was by far the wealthiest city in Scotland. The well disposed often dressed extravagantly and there were numerous wig makers. Beaverhall derives its name from beaver hats, which were made near the banks of the Water of Leith. The beaver skins were obtained in exchange for religious and political prisoners sold into bondage in the colonial plantations.

Close to Beaverhall is Powderhall, which also owes its name to an early commercial enterprise. Since 1541, gunpowder had been made at Edinburgh Castle. In 1695, William III gave exclusive rights to four Edinburgh businessmen for its manufacture, and a factory was constructed on the banks of the Water of Leith. At Leith itself there were workshops making articles in horn and ivory. By the end of the century, there were forty-six goldsmiths and silversmiths in Edinburgh when they were uncommon in other towns. George Heriot, a goldsmith to James IV, had a small shop that was said to have been only 7 feet square. He left his fortune to found Heriots School (or 'Hospital' as it was then called) for poor, fatherless children. In 1659, it had thirty pupils, the only other school of any consequence at that time being the Royal High School, which was generally restricted to the sons of the well to do. In the closing years of the seventeenth century, Merchant Maiden Hospital opened to educate the daughters of wealthy households. These households also employed numerous domestic servants, around 90 per cent of whom were women. There were 4,000 employed in this work in 1690, far more than in any other trade or profession, excepting agriculture in the surrounding countryside.

The development of the economy was hampered by poor transport. Stone was transported on horse-drawn sledges from Craigleith Quarry (opened in 1616), a couple of miles north-west of Edinburgh. There was a small number of private coaches but most people travelled on foot or horseback. The first step towards the city becoming an important hub for overland communications took place when the first public stagecoach service in Britain was introduced in 1610. It ran between Edinburgh and Leith at a charge of around two pence per person. Sedan chairs began to appear on the capital's street in 1667. They proved popular as they could negotiate the narrow streets and closes. Just over ten years later, a stagecoach service drawn by six horses began serving Glasgow, carrying both passengers and mail.

The seventeenth century came to an end with a disastrous speculative venture that was planned in Edinburgh but affected the economic prosperity of the whole country. With England profiting from numerous overseas colonies, Scotland decided to follow its example. The Isthmus of Panama (also known as Darien) was thought to be a suitable territory for this venture. Large and small investments poured in from wealthy merchants down to small savers. Five ships set sail from Leith in July 1698 carrying around 1,200 people. The expedition was a total disaster, with many members dying from disease in Panama. In addition, they were unable to sell the goods they had embarked with – including woollens that were not in great demand in the tropics! The failure of the Darien expedition was a financial disaster for Scotland. With its economy crippled, it was rushed into the Act of Union with England in 1707. This, like the Union of the Crowns just over 100 years earlier, dealt a blow to the economy of Edinburgh. It lost its parliament and many of the aristocracy departed for London. The Scottish mint in the Cowgate (which had been located in Edinburgh Castle in the mid-sixteenth century for security reasons) closed, as the country could no longer mint its own coins.

By 1707 Edinburgh had become an important centre for the making of paper with five mills on the Water of Leith, two at Darly, two at Canonmills and one at Spylaw. The mills at Dalry employed a number of foreign workmen, but the abolition of the Scottish Parliament caused a consequential loss in demand for paper. The earlier Civil War and Cromwellian occupation also adversely affected publishing and the book trade. None the less, the seventeenth century saw several important developments. The first authorised version of the bible was printed by Robert Young, printer to Charles I, but met with much criticism. Andro Anderson held the same position under Charles II, churning out endless editions of books on William Wallace and Robert Bruce. When he died in 1676, his wife took over the business and built it up into the largest printing business in Edinburgh. The books Daniel Defoe wrote while living in Scotland were published by her. She established a paper mill at Penicuik in 1709.

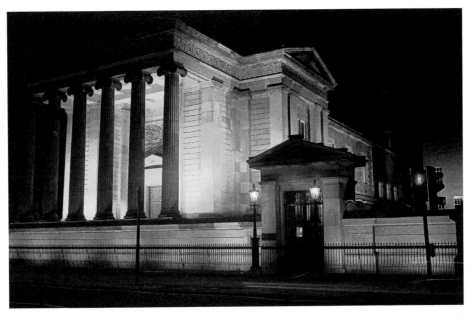

Surgeons' Hall, the headquarters of the Royal College of Surgeons, which was founded in 1505. Since then this organisation has been at the vanguard of surgical innovation, and in 2017 has over 25,000 members worldwide.

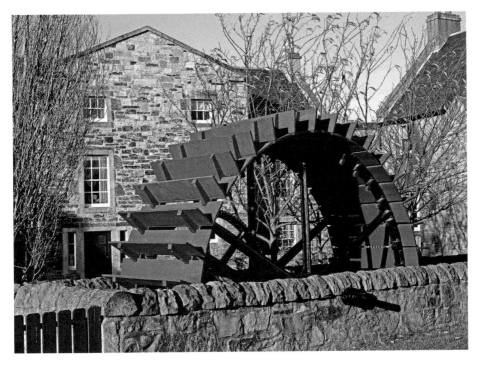

A preserved waterwheel at Bonnington, close to the Water of Leith. Flour milling had taken place in the vicinity since the Middle Ages. The waterwheel came from an eighteenth-century mill, which ceased operating in 1967.

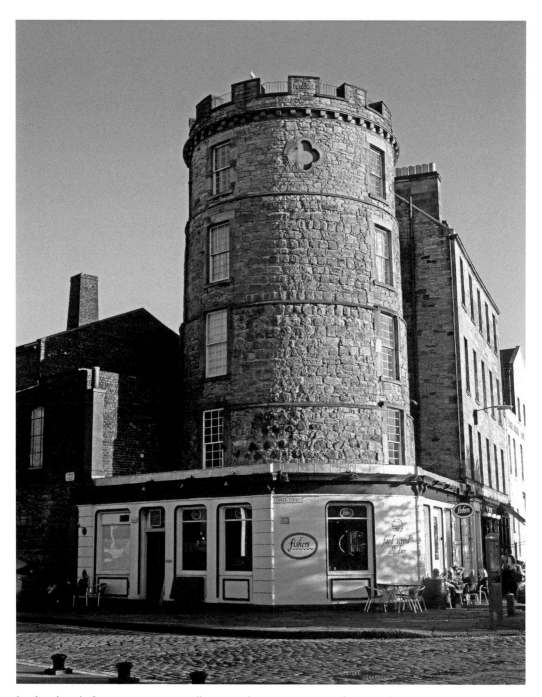

In the days before steam, watermills were the main source of power for driving industrial machinery. In addition there were a small number of windmills in the vicinity of Edinburgh. Situated on the Shore, Leith, this example was built between 1685 and 1686 to grind oil seed imported from the Baltic states. In 1805, its sails were removed and it was converted to a signal tower.

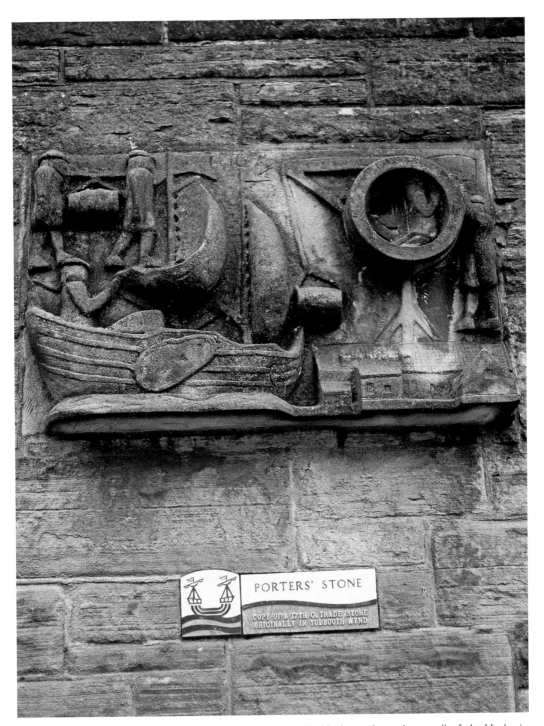

A reproduction of the Porters' Stone that is embedded in a boundary wall of the Vaults in Henderson Street. The original stone dates from 1678 and gives a pictorial representation of how wine was unloaded from a ship with a primitive crane and transported through Leith.

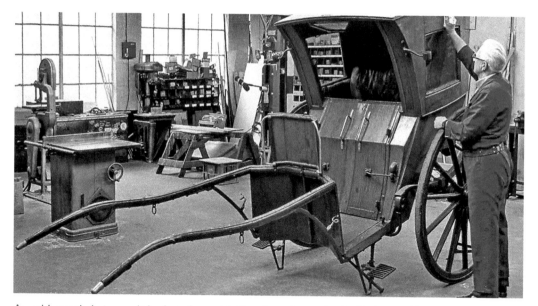

An old coach being polished at Scotmid Coachworks at Angle Park in 1992. For several centuries Edinburgh was a noted centre for the construction of high-quality coaches. (© Peter Stubbs, www.edinphoto.org.uk)

The Vaults, Leith, was built around 1682. Wine was stored in its cellars before being transported to Edinburgh. Today the building is private flats.

# THE GEORGIAN ERA, 1714–1837

The latter years of the Georgian era would see the transformation of Edinburgh from what was little more than a small medieval town, confined within its old defensive walls, into a modern city. With Scotland and England now part of Great Britain, conflict between the two countries became highly unlikely and the need for defences eliminated. In 1769, the construction of the New Town commenced on what were then open fields, greatly extending the boundaries under urban development. This employed large numbers of workers in construction, including no less than 6,000 stone masons over several decades.

The population was around 31,000 in 1755 and had grown to around 162,000 by the end of the eighteenth century. Many former agricultural workers descended on the city from the rural areas seeking employment in the expanding economy. Unfortunately not all those who settled in Edinburgh could find work and begging became rife. As the Industrial Revolution gained momentum, the traditional incorporations of craftsmen began to lose their stranglehold on the markets.

Turnpike roads were constructed to replace the muddy tracks on which trade had previously depended. This enabled businesses to serve larger markets and hence expand their premises. In 1763, there were only two stagecoach services from Edinburgh, one to Leith and the other to London. Twenty years later there was a fleet of stagecoaches travelling to just about every major town in Scotland. In 1673, there were twenty hackney coaches in Edinburgh providing a local taxi service but they did not prove popular and the number had decreased to only nine around 100 years later. The first coach-building establishment in Scotland was set up in Edinburgh around 1696. In the beginning, only coach repairs were undertaken, with some clients coming from as far away as London. A few inelegant coaches were also constructed. In 1738, John Home reorganised his coach-building business, with each of his workmen specialising in the construction of a particular part, such as the wheels. As a result of the quality of Home's work, Edinburgh soon gained a reputation for its horse-drawn coaches. A number were exported from Leith to the West Indies in 1766, and in the following years to Holland, France and Poland. In 1783 it was noted that

Coaches and chaises are constructed as elegantly in Edinburgh as anywhere in Europe. Many are yearly exported to St. Petersburg and cities in the Baltic and there was lately an order from Paris to one coach maker for 1,000 crane necked carriages, to be executed in three years.

Even with the introduction of railways in the following century, there remained a strong demand for private coaches. In the late 1860s, there were fourteen coach-building establishments employing a large number of workmen. According to a contemporary newspaper article on Scottish industries, 'Indeed, no coach makers in the world produce carriages which comfort, strength or elegance, surpass those made in that city'.

Textile manufacturing was undertaken in Edinburgh in the eighteenth century but there were never the large numbers of mills as there were in some towns in northern England. Wool had been one of Scotland's most important commodities and had been exported since the Middle Ages. By the early eighteenth century Edinburgh was an important centre for woollen manufacture.

In 1776, a Mr Loch visited Scotland and observed that a factory at St. Paul Work, Leith Wynd, Edinburgh manufactured 4,000 pounds of Scotch wool and 17,000 pounds of Spanish wool yearly with the assistance of fulling mills and a spinning machine. Merchant John Ballantyne could dye his wool to every colour except scarlet. He employed destitute boys lodged in Canongate workhouse to spin wool yarn. Two pence a pound was the price paid for combing long wool and from 1s to 1s and 3d a spindle for spinning, according to the fineness of the grist. A shilling a day could be earned by John Ballantyne's workmen 'if they chose to exert themselves'.

The woollen trade at the end of the eighteenth century concentrated on the high end of the market. It made cashmere and royal gowns, a number of which were procured by the Russian Empress. Jeeves of Edinburgh was considered 'among the best blanket makers in Great Britain'. Carpets were also woven and button making appeared at the end of the eighteenth century.

Although the making of linen cloth had been undertaken in Scotland since the Middle Ages, it underwent spectacular growth in the eighteenth century to become the country's most important industry at that time. Edinburgh had long specialised in making high-quality linen, which fetched a high price. A bleachworks was established at Corstorphine in 1698. Damask, a richly patterned linen cloth was being woven on premises at Drumsheugh in 1718. Around the same time French weavers were encourage to settle just outside Edinburgh at what is now Picardy Place in an effort to stimulate the manufacture of textiles. When the industry peaked in around 1788 there were 1,500 looms in the city, many of which had been manufactured locally by David Foullis. There was a further bleach field at Fountainbridge by the mid-eighteenth century. While much of the activity was situated on the edge of Edinburgh, there was a linen weaving works in the Canongate around this time. To promote and finance the industry, the British Linen Co. was formed. It moved into banking in the 1760s and eventually became the British Linen Bank.

When the premises of the Bank of Scotland in Parliament Square were destroyed by fire in 1700, it moved to Old Bank Close. In 1727, the Royal Bank of Scotland opened its doors for business. It was set up by investors in the failed Company of Scotland to protect the compensation they had received as part of the arrangements of the 1707 Acts of Union. The Royal Bank of Scotland competed directly with the Bank of Scotland, with each issuing its own bank notes. The former introduced the bank overdraft in 1728, considered one of the innovations of modern banking. The two Edinburgh banks concentrated their credit in Edinburgh. There were, however, no regulations in Scotland to prevent merchants setting up their own banks in other towns. For many years the Royal Bank had just one branch and, along with the Bank of Scotland, attempted to restrict competition from the provincial banks. In 1810, towards the end of the Georgian era, the Commercial Bank was founded to compete with the three established banks.

Another milestone on the way to making Edinburgh a leading financial centre occurred in 1720. A number of house owners agreed to insure each other's property against fire by making a deposit amounting to a fifteenth part of its value. Near the end of the Napoleonic Wars several new companies, including Scottish Widows, were created to assist women who had lost their husbands in the conflict. By 1826 Edinburgh was home to no less thirty fire and life insurance companies. The city was now second only to London in importance as a financial centre.

The long-established activity of brewing grew rapidly in the eighteenth century and Edinburgh had a dominant position in this activity. In 1749, William Younger set up a brewhouse in Leith, where there were many rival 'kitchen' breweries. It was his son Archibald Younger who built a large brewery at Holyrood in 1778 where there was clear springs and wells. He opened a further brewery close by at Croft-an-Righ. His strong ale became famous and was popular with customers of Johnnie Dowie's Tavern, which was frequented by Robert Burns. Archibald's brother had a further small brewery at the Canongate while his mother continued to run their family's first venture into brewing at Leith.

By 1800 there were fourteen breweries in Edinburgh, the largest concentration in Scotland. By 1802 William Younger was shipping his ale to London. Twenty years later it was being exported to the United States, West Indies and South America. The number of breweries in Edinburgh had increased to twenty-nine. Many breweries employed only a handful of workers but many other jobs depended on this industry, including blacksmiths, coopers and draymen. In 1825, Edinburgh had twenty-six cooperage firms with a further similar number at Leith.

In the late eighteenth century whisky became the most popular drink in Scotland. In 1777, the city had eight licensed stills but an estimated 400 illicit ones. There were upwards of 2,000 houses in and around Edinburgh where whisky was on sale. It was regarded as a poor man's drink, with wine and brandy being the premium tipples. Although whisky production is associated with the with remote rural areas, at one time Edinburgh and Leith were significant centres for its production and blending. Bonnington distillery, founded in 1798, later became Haigs Distillery. Alexander Law founded Yardheads Distillery in 1825 and around the same time Leith was granted one of only six licences issued to Scottish ports allowing the storage of whisky under bond.

Despite the invention of the steam engine, the Water of Leith, which flowed around the northern edge of the New Town, was still the main source of power and much of the local industry was found on its banks. By 1828 there were seventy-one mills on a 10-mile stretch of the river between Balerno and Leith, most of which was still open countryside. They included fourteen corn mills, twelve barley mills, twenty flour mills, seven saw mills, five snuff mills, five cloth fulling mills, four paper mills, two lint mills and two leather mills. Further to the west on the banks of the River Almond were the Cramond iron mills. These were the nearest thing the Edinburgh area had to heavy industry at the time. A number of corn mills were purchased in the mid-eighteenth century and converted to the manufacture of iron. By the 1790s there were three forges, two slitting mills and two steel furnaces, possibly the first in Scotland. Swedish and Russian bar iron was imported and used to manufacture a range of products, including pans for salt works, hoops for barrels and rod iron to be turned into nails. Around 12,000 spades were also produced a year. Some fifty men and boys were employed in making these goods and were paid between 3s and 20s a week. A further thirty worked on the forges and smelters. The Cramond mills continued in operation well into the Victorian era.

At the end of the eighteenth century, Edinburgh was consuming around 500 tons of coal a day. Some came from areas a handful of miles away, which are now suburbs of the city. *The First Statistical Account* written at the end of the eighteenth century relates that:

Thirteen seams of coal have been discovered and wrought upon the estate of Duddingston. About the year 1763, the Earl of Abercorn began to erect a steam engine of considerable power extending the operation to a depth of 52 fathoms [300 feet]. This steam engine was rendered useless in 1790 when the lower coal seams overflowed and choked communication with the higher levels. Before this period another steam engine of considerable power was erected on the southern edge of the parish at Brunstane. The shaft reached a depth of sixty fathoms [360 feet]. Porous quality of the rock caused water to flow into the working and made extraction of coal difficult. Before 1790, the colliery employed around 270 men.

Before emancipation miners were under the yoke of their employers and were little better than feudal serfs. Their masters often lent them money to get them further into debt. Miners who left and sought work in other collieries were often taken advantage of. Their new employers would sometimes pay off their debts, so they could have the opportunity of lending them money themselves.

Much of Edinburgh's commercial life revolved round its numerous pubs and taverns where, in the days before there were offices, businessmen would meet and doctors even carried out examinations of their patients. The first coffee house opened around 1673 in Parliament Close. Oysters from the Firth of Forth were a favourite food in the pubs. In 1778, 8,400 barrels of oysters were exported from the city's fishing grounds. Overfishing led to a serious depletion of this resource, despite attempts to restrict its exploitation. Strawberries grown in the vicinity of Edinburgh were a seasonal delicacy being consumed in the pleasure gardens and places of entertainment.

In the 1770s, travel writer Edward Topham complained about the inadequate accommodation found in Edinburgh:

One can scarcely form an imagination [of] the distress of a miserable stranger on his first entrance into the city, as there is no inn better than an alehouse, nor any accommodation that is decent, cleanly or fit to receive a gentleman.

These inns were generally concentrated around the former gates of the Old Town, in the Grassmarket, Candlemaker Row and at The Pleasance. The situation was about to change with hotels beginning to make their first appearance in the city, particularly in St Andrews Square and the New Town. It was not until the construction of the railways in the next century that they became a common feature in Edinburgh. By 1826 Edinburgh had around twenty hotels. At the same time there were 178 tavern keepers, vintners and publicans.

The city gained fame in the eighteenth century, not for its industries and manufacturing but for its contribution to learning and literature. In 1769, there were 600 students at Edinburgh University, but twenty years later the numbers had increased to 1,100, including 400 studying medicine. The first Edinburgh infirmary opened in 1729, not long after the university's medical school. Between 1738 and 1741, the second Royal Infirmary was constructed in what is now Infirmary Street. When it opened it had sixty to seventy beds, which was soon increased to over 200. Between 1762 and 1775, 15,600 patients

were admitted, of which 11,700 were discharged as cured and some 750 died. The Royal Infirmary was closely associated with Edinburgh University and the professors of medicine gave clinical lectures on selected cases. The students also attended the Royal Infirmary for instruction. The death rate among its patients was half that of many prestigious European hospitals. Edinburgh was beginning to gain a reputation for medical excellence in part due to teaching being based on science.

In 1740, there were just four printing firms in Edinburgh, but by 1770 the number had risen to twenty-seven. Printing was becoming one of Edinburgh's most important industries. Its growth was simulated by the city becoming an important intellectual centre. At a time when the restrictive practices of the guilds were coming to an end, Adam Smith wrote *The Wealth of Nations*, which advocated free trade. Although born in Kirkcaldy, he lived out the last years of his life in Edinburgh. The popularity of the novels of Sir Walter Scott and the poet Robert Burns created a surge in the demand for books. The first edition of the *Encyclopaedia Britannica* was produced and published in Edinburgh between 1768 and 1771. Thomas Nelson & Sons started printing and publishing in 1798 and Adam and Charles Black founded their well-known publishing business in 1806. In addition, two newspapers were printed in Edinburgh in the mid-eighteenth century with the number having grown to six by 1792. By 1826 the Pigots Trade Directory lists some eighty-five booksellers and stationers. It states:

In Edinburgh there are few general merchants as most of them reside in Leith. There are a vast number of shopkeepers and the support of the city in this respect depends on the consumption of the necessaries and superfluities of life.

Among those listed (excluding Leith) are 230 grocers, 180 butchers and no less than 450 spirit dealers. There were also 186 boot and shoemakers, 24 hat manufacturers and dealers, 40 jewellers and 15 toy dealers. Some 27 perfumers are listed, although a contemporary source relates that this profession did not exist in the mid-eighteenth century. By 1783 their shops could be found in every principal street. Some of them advertised the keeping of bears, killed to obtain their fat, thought to be superior to any other animal fat for greasing the hair of ladies and gentlemen. The number of hairdressers had more than tripled between 1763 and 1783. Starch was manufactured locally and much of the output was used as hair powder. The construction of spacious houses in the New Town required more furnishings than their predecessors. The owners usually employed maid servants to assist them in looking after their property. Towards the end of the eighteenth century, affluent families also had a man servant whose wages were £10 to £20 per year.

At the end of the eighteenth century, there were 165 vessels registered at Leith. The largest were used to catch whales off Greenland, but most were engaged in trade. Lead, glassware, linen and woollen stuffs were exported to Germany and the Netherlands. Large amounts of grain were imported, as well as timber, hides, linen rags, hemp and tar. Wine arrived from France and brandy from Portugal. In the 1720s many of the wholesale traders in the West Bow had their warehouses in Leith. They dealt with a wide variety of items that included tar, oil, hemp, flax, paints, dyes, and iron pitch. Clustered around the port were numerous industries. In 1791, John Heron related that 'ships of considerable size are built at this port and several extensive rope works are here carried on. The flourishing manufacture of bottle-glass, window-glass and crystal has long employed three glass houses and three others have lately been erected. A carpet manufacture, a soap work and some iron forges are also worthy of being mentioned.'

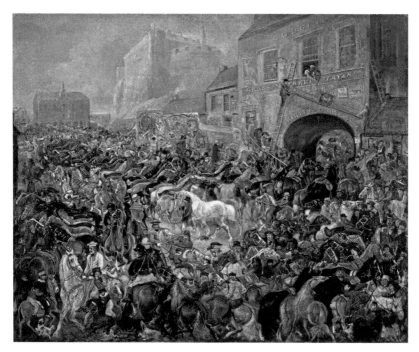

A horse fair in the Grassmarket depicted by the artist James Howe, who lived towards the end of the Georgian era. In those days, Edinburgh was an important livestock market with large numbers of oxen, sheep and pigs being brought here for slaughter. (Edinburgh Libraries, www.capitalcollections.org.uk)

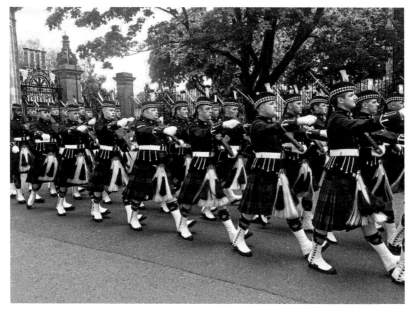

Soldiers march past in 2017. In bygone centuries, Edinburgh Castle had a large garrison, particularly after the 1745 Jacobite Rebellion. The soldiers would spend their meagre pay in the city's shops and pubs. (City of Edinburgh Council)

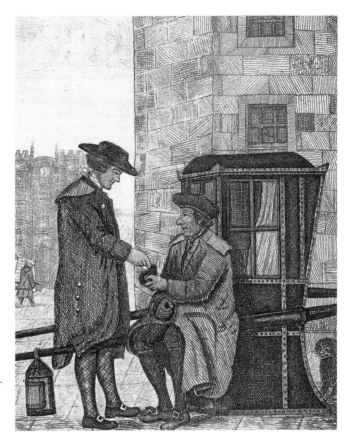

*Right:* Sedan chairs were a popular method of transport in eighteenth-century Edinburgh. Some were privately owned while others could be hired like taxis today. Two men, known as 'chairmen', were needed to carry each chair. (Edinburgh Libraries, www. capitalcollections.org.uk)

*Below:* Preserved limekilns at Gilmerton. Both coal and limestone were once mined on what is now the southern edge of Edinburgh. The latter was burnt in limekilns to produce a fertilizer for agriculture.

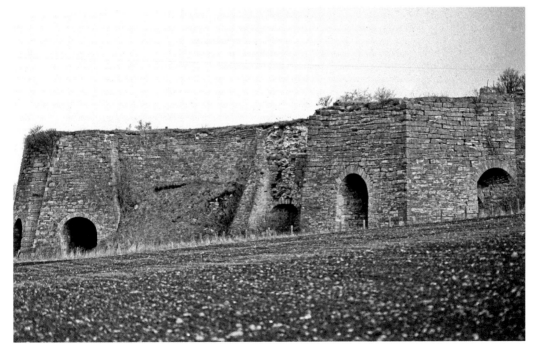

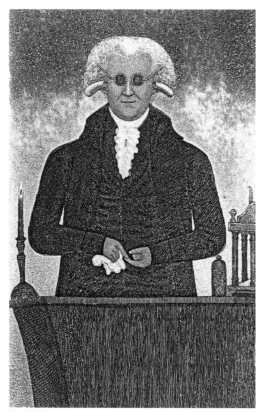

An etching of Dr Henry Moyes in 1796 by John Kay. He travelled widely giving public lectures on chemistry, raising interest in the sciences. At the age of three he contracted smallpox, which blinded him – hence his dark glasses. (Edinburgh Libraries, www.capitalcollections.org.uk)

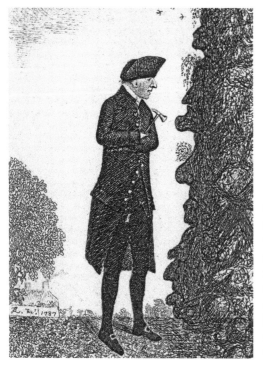

Dr James Hutton standing in front of a rock face. He was one of the leading figures in the Scottish Enlightenment of the eighteenth century. He originated the theory of uniformitarianism, a fundamental principle of geology that explains the features of the earth's crust by means of natural processes such as erosion over time. (Edinburgh Libraries, www. capitalcollections. org.uk)

*Above*: Edinburgh was one of the first places in Scotland where woollen goods were made and it had one of the most important wool markets. The manufacture of woollen goods in Edinburgh has long vanished and the only reminder of this former activity is in shops such as this.

*Right*: The Old College of the University of Edinburgh looms over the Old Town. Its construction commenced in 1789, although the dome was not built until 100 years later.

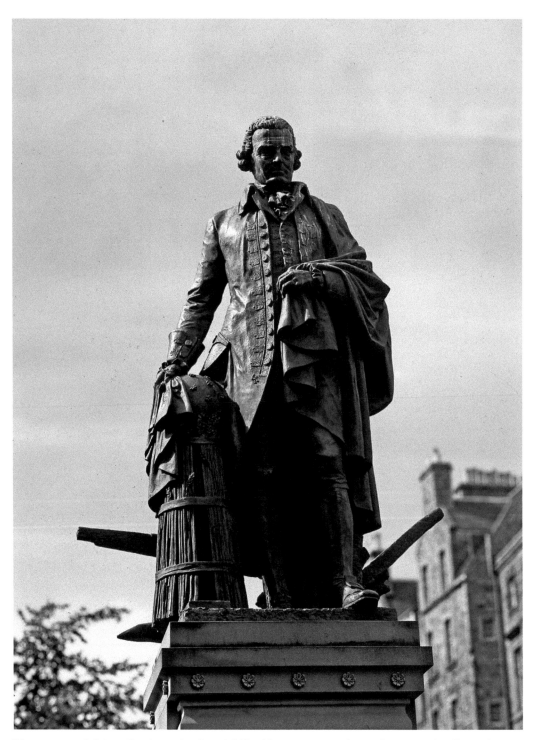

The statue of Adam Smith in the Royal Mile. He was a prominent figure in the Scottish Enlightenment in the late eighteenth century and wrote *The Wealth of Nations*, considered to be the first modern work on economics.

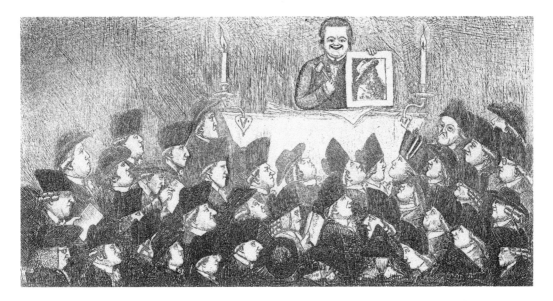

*Above:* William Martin, bookseller and auctioneer, displays a painting in front of potential bidders, *c.* 1800. (Edinburgh Libraries, www.capitalcollections.org.uk)

*Right:* Margaret Suttie, a hawker of salt depicted in 1799. She carries her goods on her back. Around this time, there were forty salt carriers, all women, who ferried salt from the vicinity of Portobello to Edinburgh on foot. (Edinburgh Libraries, www. capitalcollections.org.uk)

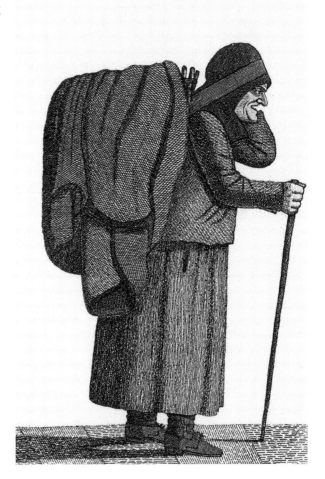

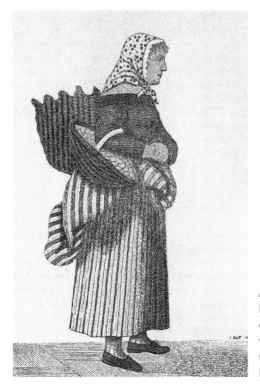

An etching by John Kay, 1812, of an Edinburgh fish woman holding a basket of oysters. Locally harvested oysters were a very popular delicacy and were exported to England and the Continent. (Edinburgh Libraries, www.capitalcollections.org.uk)

Chimney sweeps depicted at the beginning of the nineteenth century. Unlike some trades, it was relatively recent as chimneys did not appear in houses until the sixteenth century. (Edinburgh Libraries, www. capitalcollections.org.uk)

The Bank of Scotland constructed their head office on the top of the Mound on the edge of the Old Town in the early nineteenth century. In 2017 it remains the headquarters of the Bank of Scotland, now part of the Lloyds Banking Group.

St Andrew Square was at the heart of Scotland's banking system in the nineteenth century. The Royal Bank of Scotland moved its headquarters here from the Old Town in 1821. At the beginning of the twenty-first century new headquarters were constructed at Gogarburn, near Edinburgh Airport.

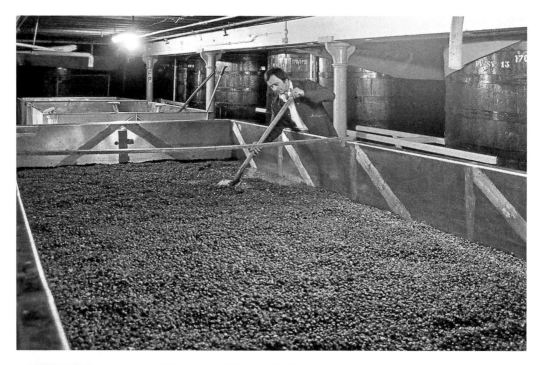

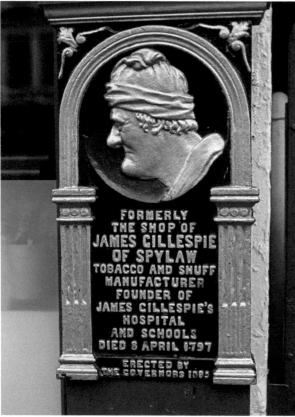

*Above*: Crabbie's Green Ginger wine is a Leith invention dating from 1801, as is Rose's Lime Juice, which was originally a cordial used to fortify sailors against scurvy. Raisins are seen in the tank at the premises of Crabbie's Green Ginger at Great Junction Street in 1992. (© Peter Stubbs, www.edinphoto.org.uk)

*Left*: A plaque marking the site of James Gillespie's tobacco and snuff shop in the High Street, close to St Giles' Cathedral. In 1803 James Gillespie's High School was founded with a legacy left by him.

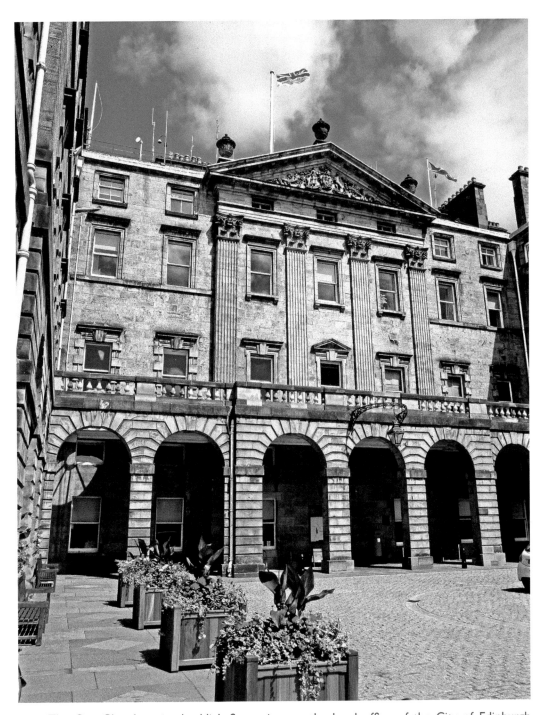

The City Chambers in the High Street is now the head office of the City of Edinburgh Council. It was constructed in the mid-eighteenth century as an Exchange in which merchants could conduct their business. In this respect it was a failure, as they preferred to stand in the open in the High Street to carry out their transactions.

# THE VICTORIAN ERA, 1837–1901

Edinburgh's demand for coal was the main driving force behind the construction of the Union Canal, which opened in 1822. It in turn encouraged the development of industry around its terminus at Fountainbridge. Inland waterborne transport was soon eclipsed by the building of the railways. They were synonymous with the Victorian era and enabled industrialisation to increase at a rapid rate. The first railway to serve Edinburgh was known as the Innocent Railway and terminated at St Leonards. It supplied the city with coal transported by horse-drawn wagons.

The Edinburgh & Glasgow Railway opened a terminus at Haymarket in 1842. Four years later tunnels were dug to connect it with the North British Railway station at Waverley. In 1850, the Edinburgh, Leith & Granton Railway linked Fife with the world's first roll on, roll off ferry, which transported complete trains. A wedge of land devoted to industry grew up along the railways in the Haymarket Gorgie, which still exists today. The coming of the railway also laid the foundations for the modern tourist industry. By the 1850s, Thomas Cook was running organised trips to Edinburgh.

Despite Edinburgh having numerous railway lines converging on it, manufacturing had a relatively low profile compared with other towns in Victorian Britain. It did not have large numbers of 'dark satanic mills' with forests of tall chimneys belching smoke. Nonetheless, it did produce a wide range of products as well as having a number of key industries. The long-established brewing industry saw considerable growth and it had become a dominant force by the end of the nineteenth century. In the 1830s, its products were already being sold as far away as Aberdeen, Orkney, the Shetlands, Tyneside and London. As communications improved, the country breweries disappeared and were replaced by larger examples in urban areas such as Edinburgh. Many were still concentrated over the aquifer in the Holyrood area, which supplied them with water from wells. William Younger had its premises here and not far away the Abbey Brewery was built by Robert Younger at the end of the nineteenth century. New breweries were also constructed away from the traditional source of water. Around 1866, Jeffrey & Co. created a new brewery at Roseburn. Drybrough's brewery moved to Craigmillar in 1892. By 1896, of the ninety-nine breweries in Scotland, thirty-one were located in Edinburgh.

Although distilleries are usually associated with the Scottish Highlands, they could also be found in Edinburgh. In 1881, James Johnstone converted the Dean Mills into the Dean Distillery, which produced 330,000 litres (75,000 gallons) of lowland malt whisky in 1886. In 1855, a huge complex was built next to Haymarket station by Menzies, Bernard & Co.

to produce grain whisky. Known as the Caledonian Distillery, in 1869 it had 150 employees producing 9 million gallons annually. Much of the grain spirit was transported to London where it was turned into gin. The distillery continued in operation until 1988. The failure of grape harvests in southern Europe between 1873 and 1876 allowed whisky to assume a dominant role in Leith. Many of the 100 or so bonded warehouses that once stored wine and brandy were now used for whisky. Even as late as the 1960s, around 85 per cent of the output of Scottish distilleries was left to mature in Leith's warehouses.

Andrew Usher, who owned the Sciennes Brewery, purchased the so-called 'Glen Sciennes' pot distillery and renamed it 'The Edinburgh Lowland Malt Distillery'. He is credited with having founded the modern blending industry by adding grain whisky to make the premium product go further. This was initially undertaken in a large bonded warehouse beside Holyrood Park. A co-operative of whisky blenders under the leadership of Andrew Usher opened the North British grain distillery a short distance to the west of the Caledonian Distillery in 1887. It had a capacity of 2 to 3 million gallons a year. Some of the profits from Andrew Usher's distilling business was used to build the Usher Concert Hall. Whisky blending was undertaken at Leith with five firms being involved in this activity in 1887.

Non-alcoholic beverages in the form of aerated mineral waters became popular towards the end of the nineteenth century when there were over thirty businesses producing them in Edinburgh. Ginger beer was particularly popular. Among the best-known companies was Dunbars, which began supplying the market in the late 1860s. Along with drink, food processing was an important industry with numerous bakers and confectioners scattered across Edinburgh. Mary Duncan and her son founded a cake business in 1861. Twenty-three years later, the business transferred to the High Street in Edinburgh and began to make chocolate confectionery. In 1894, it moved to the Regent Confectionery Works in Beaverhall Road. It remained there for nearly a century and the popularity of its products made it a household name.

Unlike brewing, which had a long history, the biscuit industry had its origins relatively recently in the early nineteenth century. It became so successful that it was considered, along with brewing and printing, one of Edinburgh's three sources of wealth. Robert Middlemass started biscuit production in 1835. A large factory was constructed in Causewayside in 1869 and employed mainly women. There were few opportunities for females at that time, other than in domestic service, which employed many thousands. Another well-known biscuit firm had its origins in Edinburgh. In 1830, Robert McVitie and his father opened a provisions shop in Rose Street. Its baked products were so popular that a chain of shops were soon opened across the city. In 1888, Alexander Grant began working for the family business and created the recipe for the digestive biscuit, which is still in use today, although McVitie's no longer have a presence in Edinburgh.

Most food could not be transported long distances as it perished quickly. There were market gardens that grew fruit and vegetables on the edge of the city and around Musselburgh and Prestonpans. There were over 350 dairy keepers listed in the directory of 1894. It was not unusual for small numbers of cows to be kept in built-up areas to supply fresh milk.

The Victorian era saw the introduction of preserved food. At the beginning of the nineteenth century, a Frenchman, Monsieur Appert, invented a method of preserving meat and vegetables by heating and sealing them in an air-tight vessel, which in time became the 'tin can'. The meat-preserving trade was introduced into Scotland in 1822 and around fifty years later there were nine factories in the country involved in this activity. One of the largest was John Gillon & Co., located in Mitchell Street, Leith. The firm produced a staggering 500 varieties of meats, soups, vegetables and fish in uniform red-painted cans, labelled to describe their contents.

The tin cans were produced by machines operated by men and boys who could be trained in a matter of a few weeks. The ships of some of the early Arctic expeditions were supplied with provisions prepared by Gillon and Co. Many European governments were their customers, as were British citizens living in India and other parts of the Empire.

Although Edinburgh was not famed for its engineering industries, they played a significant role in its economic life. By the 1840s, Mortons of Leith were successful shipbuilders and built numerous paddle steamers over the next few decades. By 1882 there were no less than seven shipyards turning out a variety of vessels from trawlers to iron steamships. Steam locomotives were also fabricated at Leith. Later in the nineteenth century, trams were introduced onto the streets of Edinburgh, many of them being built at the depot at Shrubhill. Cycling had become a popular activity towards the end of the Victorian era and there were over twenty bicycle and tricycle manufacturers, mostly small-scale enterprises. Some of the engineering firms specialised in supplying machinery for local industries. For example, Bertrams Ltd was founded in 1821 by two brothers who made paper-making machinery at Sciennes.

Although Edinburgh lacked the raw materials for heavy industries (unlike Glasgow and Lanarkshire) it had foundries since the mid-seventeenth century. By 1868 the city had four extensive brass foundries, which chiefly made items for plumbing. They employed around 800 workers, about one third of the entire workforce in this industry in Scotland. The brass foundry of Milne & Son was located in the Canongate and covered over an acre. The company specialised in making gas meters and employed over 350 people. The last traditional brass foundry in Britain was located at Beaverhall, Edinburgh, until the early years of the twenty-first century, when it moved to Fife. In the mid-nineteenth century, Campbell & Co. at Leith were Scotland's largest lead and zinc manufacturers.

Edinburgh became a major centre for the manufacture of rubber goods, but this was due more to a quirk of fate than to its proximity to natural resources. Thomas Hancock of Charles Macintosh & Co. applied for a patent for the vulcanisation of rubber in England in 1843, beating the American Charles Goodyear by a few months. Goodyear had actually discovered the process, but some time earlier had forwarded a sample of vulcanised rubber to Thomas Hancock, who figured out how it had been formed. A separate patent was needed for Scotland and Charles Goodyear, not to be outdone, was first to apply for it in 1844. Castle Mills had been built at Fountainbridge a few years earlier for the production of silk but the venture failed. It was lying empty and was converted for the production of rubber boots and shoes. The Goodyear patent was later acquired so the factory had sole right to produce vulcanised goods in Scotland. This is thought to have been the first direct investment of US capital in a British manufacturing industry. By the 1860s it employed 600 workers and turned out 2 million pairs of women's waterproof shoes a year, along with other rainproof clothing. Next to it was the Scottish Vulcanite Co.'s factory, a subsidiary that employed a further 500 workers. It produced moulded goods from rubber-based plastic, including 7.5 million combs each year. By the 1890s the North British Rubber Co. employed 1,600 people at their Castle Mills Works at Fountainbridge. Flexible rubber tubing utilised in the construction of the Forth Rail Bridge came from here. There were also a number of other smaller companies in Edinburgh and Leith that produced products made of rubber.

According to a contemporary source, Edinburgh's principal industry in the late 1860s was printing and its associate trades, in which around 5,000 were employed, half of the Scottish total. At this time, Thomas Nelson was the largest company. Its premises at Hope Park also manufactured printing ink and bound books. It had a workforce of 440 people, half of

them women. R. and R. Clark, founded in 1846 and whose premises were at Canonmills, claimed the distinction of having trained Fanny McPherson to be the first woman compositor. She subsequently trained other women and remained with the firm for sixty years. It was thought that there were not more than twenty-four women in Britain earning a living as operative printers in 1869. Other notable companies included Oliver and Boyd, which specialised in school books. By 1869 Neill & Co. had been in business for 100 years and had recently produced the eighth edition of the Encyclopaedia Britannica. Although many industries had left the Old Town in the Victorian era for larger premises on greenfield sites at the edge of the city, this printer still occupied the same buildings in Fishmarket Close in 1890 that it had first used in 1769. Such working environments were hardly conducive to the health of the workers. Printing may not be thought of as a particularly hazardous occupation, but in the nineteenth century it took a high toll of its workers. Out of thirty-five printers who died in 1866, fourteen died of pulmonary tuberculosis; many spent long hours standing in confined spaces exposed to noxious fumes.

More fortunate were the large numbers of staff employed in Edinburgh's booming financial sector. The city had a higher portion of professional workers than almost any other town. As well as several major banks having their headquarters here, there were over 300 insurance and investment companies by the early 1890s. Among the better-known firms were the Scottish Equitable Insurance Co., founded in 1831, followed by the Scottish Provident Institution in 1838, then the Scottish National Insurance Co. in 1841 and the Scottish Insurance Corporation in 1877. The railway boom in the middle of the nineteenth century created a great demand for the services of stockbrokers. The City of Edinburgh Stock Exchange was formed and initially met in rooms in St Andrew Square. In 1888, it had its own building, constructed on a site at the Corner of North St David Street and Thistle Street. The Scottish Stock Exchange existed until 1973, by which time its main office was in Glasgow.

Towards the end of the nineteenth century, Edinburgh also began to regain its position as an administrative centre for Scotland. Various government departments concerned with its affairs began to migrate north from London. The Scottish Fisheries Board was formed in 1882 with the task of protecting this resource. It was followed the next year by the Scottish Education Board and then the Crofters Commission. Edinburgh's position as a major centre of learning was further enhanced with the establishment of several public schools, including Edinburgh Academy, Daniel Stewarts and Fettes College. Edinburgh University was becoming famous, particularly for its medical discoveries. Sir James Simpson was the first person to employ chloroform in surgery. In 1893, the first women student graduated from Edinburgh University. Up until that time, professional occupations had been almost solely occupied by men.

The Industrial Revolution brought with it an enormous expansion in the availability of consumer goods. This gave rise to a great increase in both the number and range of shops. Shortly before Victoria ascended to the throne in 1837, Edinburgh had approximately 330 grocers and spirit dealers, 200 bakers, 200 boot and shoemakers, 180 milliners and dressmakers, 120 butchers, seventy drapers, 100 victual dealers, over 100 booksellers and stationers, about fifty coal merchants and some 300 to 400 other retailers. Shops in the High Street included spirit dealers, silversmiths, hairdressers, butchers, saddlers and tailors. Princes Street, although originally intended to be a residential street, had numerous shops by this time including spirit merchants, leather merchants, bootmakers, watchmakers and drapers. George Street, as well as numerous financial offices, also had many retail outlets.

The modern chain store reached Edinburgh in the last decades of the nineteenth century. Lipton the grocer had one branch in 1882 and by 1900 had six. The first example of a

department store appeared in Princes Street in the 1890s. Unlike factory workers, who had their working hours restricted by the mid-nineteenth century, there was no limitation on the hours of a shop worker – hence the shops could remain open for longer hours. Trade Unionism was particularly weak in this sector.

Railways arrived on the scene at the beginning of the Victorian era and as it drew to a close another revolutionary innovation began to transform society further, namely, electricity. A power station which was built in McDonald Road in 1898, still survives in 2017, along with its tall chimney. It was operated by Edinburgh Corporation to provide street lighting. The Corporation also had control of the city's gas supply by this time. A large new gasworks was constructed at Granton on 106-acre site between 1898 and 1906.

Leith was still a separate town at this time but was no longer under the heel of Edinburgh, which had controlled its businesses and trade up until 1830s. At the beginning of the nineteenth century, the first docks were built on either side of the river mouth. There was still no large deep water port on the south side of the Firth of Forth and to remedy this a harbour was constructed at Granton, around 2 miles to the west. Unlike Leith, which had a long maritime history, Granton was a totally new creation. It opened on 28 June 1838, the day of Queen Victoria's coronation. As at the Port of Leith, industries sprung up in its vicinity. A. B. Fleming constructed a chemical works and factory in 1872 to supply printing inks for Edinburgh's printing industry. By the following century its products were in demand across the globe. Esparto grass was imported through Granton for the local manufacture of paper. By the 1880s, the harbour had become a major fishing port, being home to around eighty trawlers. Leith by this time had eclipsed Granton as a major port with the construction of a series of ever-larger docks on reclaimed land handling greater quantities of cargo.

During the Victorian era there were numerous industries in Leith including the manufacture of barrels, flour, glassware, sails and ropes. In 1846, the manufacturer R. and W. Hawthorn established a works at Leith to assemble its locomotives, which were part-built in Newcastle. It later became Hawthorns & Co., which produced some 400 locomotives up until 1872. Interestingly, in 1834, before the widespread introduction of the railways, the Grove House Engine Works in Edinburgh had built six steam carriages, designed by John Scott Russell. They were one of the first attempts at mechanised road transport and were used to carry passengers between Glasgow and Paisley. Although they were initially successful, canal owners saw them as competition, and were opposed to their introduction. A boiler explosion after an accident allegedly rigged by turnpike trustees (who thought the carriages were damaging the road) destroyed confidence in the steam carriages and this innovative enterprise came to an end.

Portobello in Victorian times was separated from Edinburgh by open countryside. It had a cluster of industries, the most important being the manufacture of pottery using clays dug locally. At the end of the nineteenth century, there were around eighty potteries in Scotland, of which sixteen were located between Portobello and Prestonpans. The chief products were ornamental earthenware jugs and small decorative figures such as fishwives, soldiers, cows and horses, which were sold as mantelpiece ornaments. The pond in Figgate Park is a remnant of an old clay works. Waverley Pottery on Harbour Road was acquired by the Buchan Family in 1867 and renamed the Thistle Pottery. There was also a brickworks and a factory producing bottles. Paper, soap and mustard were also made here. In 1901, the year Queen Victoria died, Portobello became part of Edinburgh.

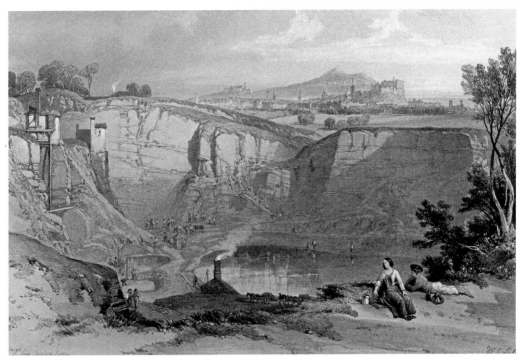

A painting of Craigleith Quarry in 1854. It supplied much of the sandstone for the construction of Edinburgh's New Town. The quarry was first worked in 1615 and at its height it employed hundreds of men with dozens of carts. (Edinburgh Libraries, www.capitalcollections.org.uk)

St Leonard's Brewery, which was built between 1889 and 1890 for G. MacKay & Co. Ltd. It survived the mergers and mechanisation of breweries in the late 1950s but closed a few years later. The building was demolished in the 1970s (© Royal Commission on the Ancient and Historical Monuments of Scotland, SC618041/Licensor Scran)

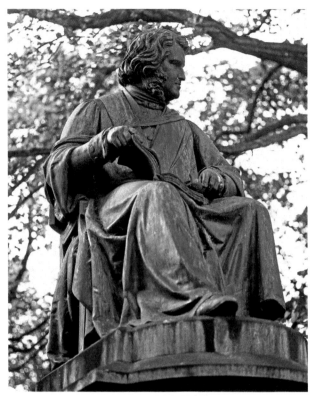

Statue of James Young Simpson in West Princes Street Gardens. He was professor of medicine at the University of Edinburgh and the first physician to demonstrate the anaesthetic properties of chloroform on humans in 1847.

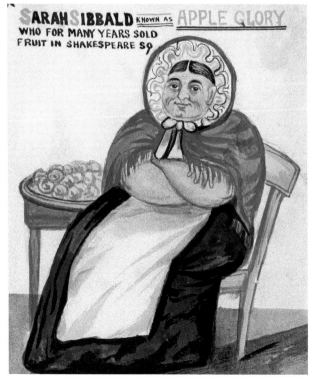

Sarah Sibbald, a fruit seller in the long-vanished Shakespeare Square, which was located close to Waverley station. (Edinburgh Libraries, www. capitalcollections.org.uk)

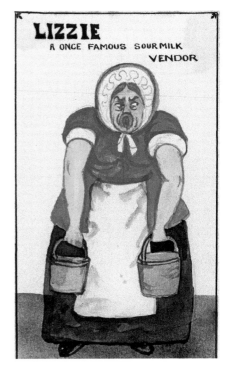

Jock Drice, a cart driver, painted by Edward Holt in 1871. Although the railways carried much of the freight traffic by this time, horse-drawn carts continued to be used in large numbers well into the twentieth century to make local deliveries. (Edinburgh Libraries, www.capitalcollections.org.uk)

Lizzie, a well-known milk vendor in Victorian Edinburgh. For many years, a city ordinance banned milkmaids from Edinburgh on a Sunday. This is another painting by Edward Holt whose works were not known for their artistic skill or subtlety. (Edinburgh Libraries, www.capitalcollections.org.uk)

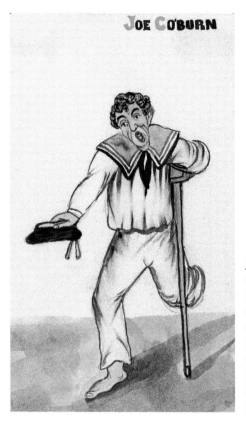

Joe Co'burn, a street beggar in a seaman's uniform, holds out his naval cap to passers-by. He was painted by Edward Holt, who specialised in depicting characters seen on the streets of the Old Town. Unemployment benefit was not introduced until the early twentieth century. Before then many individuals had no recourse other than to beg on the streets of Edinburgh. (Edinburgh Libraries, www.capitalcollections.org.uk)

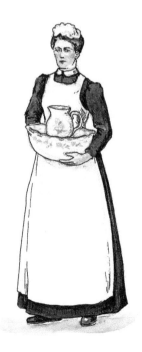

A domestic servant in the nineteenth century. In Victorian Edinburgh this job offered women the prospect of employment when few other opportunities were available. (© Dianne Sutherland, Licensor Scran)

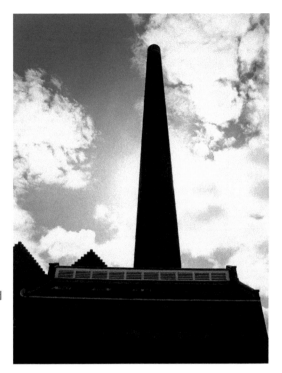

Although it closed in 1988, the preserved chimney of the Caledonian Distillery still looms over Haymarket. It was once the largest distillery in Scotland, producing grain whisky.

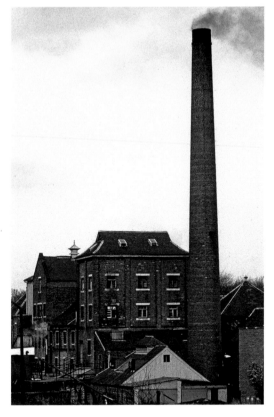

The Caledonian Brewery in the late 1970s. In the early twenty-first century it is the only working brewery left in Edinburgh. It is owned by Heineken, who also have their British headquarters in Edinburgh.

Like many other well-known Edinburgh public schools, Fettes College was founded with a large bequest from a wealthy city merchant, Sir William Fettes. The school was founded in 1870 and over the years has gained an international reputation. Former British Prime Minister Tony Blair was a pupil here, and in fiction so was the secret agent James Bond.

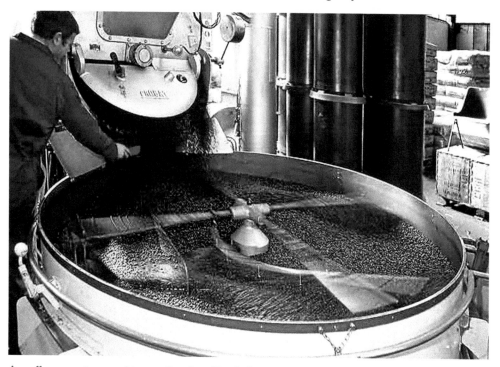

A coffee roasting machine at Brodies, Dock Street, Leith, in 1994. The company has been trading in tea and coffee since 1867. (© Peter Stubbs, www.edinphoto.org.uk)

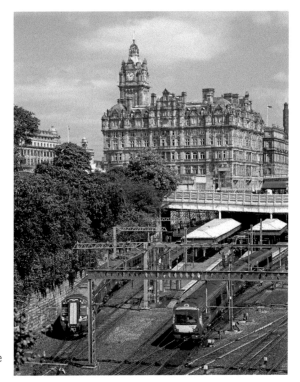

Waverley station with the Balmoral Hotel in the background in Edinburgh. The construction of the railways acted as a catalyst for the opening of large hotels like this in the centre of Edinburgh.

The Bank of Scotland law department, head office, 1890. (Courtesy of Lloyds Banking Group plc archives)

# THE TWENTIETH CENTURY

The dawning of the twentieth century saw two major developments in transport – motorised road transport and (later) the aeroplane. Edinburgh was not slow in attempting to capitalise on these innovations, but achieved limited success. The Madelvic Motor Carriage Co. was founded by William Peck to develop electric products. Between 1898 and 1900 it produced an electrically driven vehicle powered by batteries. Peck provided a public transport service between Granton and Leith to gain publicity. Despite its revolutionary product, the Madelvic Co. went bankrupt in 1900 and was taken over by the Kingsburgh Motor company. The first private car in Edinburgh was registered in 1903. Some years later, Stirling's Motor Carriages Ltd built buses in the former Madelvic factory at Granton, some of which were exported to Australia. Vehicle production at Granton came to an end in 1925. John Gibson, bicycle makers in Leith, ventured into aeroplane manufacturing between 1910 and 1913. This was the only attempt of its kind in the vicinity of Edinburgh.

Increasing demand for consumer products led to a demand for packaging for them. William Thyne established the first carton manufacturing business in Edinburgh at his Lochend Works in 1908. Hugh Stevenson, a Manchester firm, opened a factory in the following year and not long after was said to have been producing cartons for 'virtually every shop in Princes Street'. In contrast, a long-established industry that was still in business at the beginning of the twentieth century was the manufacture of clay smoking pipes. The most prolific company was Christie's, which had premises in St Anthony Lane, Leith, and was in 1904 the largest concern of its type in Britain, producing 100,000 clay pipes a week. The clay came from Cornwall and Devon. Around this time there were around 170 tobacconists shops in Edinburgh.

During the First World War, the British invented the tank and in the latter stages of the conflict deployed it on the battlefields of France. Brown Brothers at their Roseburn Iron Works in Broughton Road constructed a number of these armoured vehicles for the Army. Large numbers of men engaged in the armed forces opened up the labour market at home and women replaced them in many jobs. In 1916, the Bank of Scotland took on its first female employee.

In the years immediately after the First World War, Edinburgh continued to rely on its traditional industries. While electrical consumer goods, such as refrigerators and radios, were manufactured in southern England between the two world wars, this new industrial activity remained entirely absent in Scotland's capital city. The main industries in Edinburgh in 1921 were listed in a publication promoting its economic development:

shipbuilding and repairing, marine and other high class engineering, steel constructional and chilled casting work, rubber and vulcanite, biscuits and confectionery, making of spades and shovels, motor and motor car works, brewing, distilling, malting, chemical industries, chemical fertilisers, soap, salt, cement, paper, glue and gelatine, glass, earthenware and pottery, bricks and tiles, tanning and leather, carpets, hosiery and woollen goods, dye and bleaching, printing, bookbinding, lithography and publishing, creamery, furniture and upholstery, wire drawing, aeroplane accessories, flour, meal, printing ink and other minor industries.

The Castle Mill rubber works at Fountainbridge was at that time the largest in the British Empire. 'Scotch Glue' had an international reputation and its best known manufacturer was J. & G. Cox at Gorgie Mills, established as far back as 1725. It was the largest company of its kind in Great Britain. There were twenty-four breweries in 1921 with 70 per cent of Scotland's beer being made here. The brewers used locally grown and imported barley. According to *Industrial Edinburgh,* 1921,

Such is the fame of Edinburgh ales that it may be said that they are used in nearly every country in the world ... Originally the Edinburgh Ales were heavy and sweet in style but gradually a change in the public taste set in for lighter beers and at the present day Pale Ales of a delicate character are almost exclusively in demand.

William Younger installed a modern bottling plant at Holyrood in 1920, which had a capacity of 1,200 screw-top pint bottles of sparkling ale per hour. Edinburgh also had two of the largest distilleries in the country, although they specialised in the production of grain whisky. The baking and manufacture of biscuits was a major employer, with much of its output being exported. The largest margarine factory in Scotland, situated at Craigmillar, supplied both home and overseas markets.

Of all the industries in the city, printing at this time had the largest workforce. Books were produced for both the British and American market as Edinburgh printers had a reputation for extremely high standards with few typographical errors. In 1939, St Andrews House, a huge government building on Calton Hill, was opened which allowed work to be transferred from the Scottish Office in London, thereby increasing the trade for printers.

During the interwar year there was also an influx of popular chain stores, such as Boots and Woolworths, into the centre of the city. Despite the widespread use of cars and lorries, railways still played a vital role in the city's economy. In 1939, they employed 6,570 people in Edinburgh. There were thirty-six passenger stations and thirty-one goods stations. No less than 120 firms, including twenty-six breweries and distilleries, had their own sidings.

During the Second World War, Edinburgh was unscathed by heavy bombing raids due to its relative lack of strategic industries. Nonetheless, it still made a considerable contribution towards the war effort. In 1939, the large SMT bus garage at Fountainbridge was converted into a munitions factory. On its top floor heavy guns were manufactured. Aero engines were assembled at Haymarket skating rink and amphibious vehicles were turned out at an improvised factory in Marine Gardens. At Leith, Robb's shipyard constructed forty-two naval vessels, most of them corvettes and frigates, as well as fourteen merchant ships.

Bruce Peebles had begun making large dynamos as early as 1898. Early the following century, their works at East Pilton started manufacturing large-scale electrical generators for power stations both in Britain and its overseas territories. With this experience in producing electrical items, Peebles made searchlights, mobile transformers and minesweeping equipment for the Royal Navy during the war. George VI and Queen Elizabeth visited the works in 1942 and again in 1944, such was the company's importance in the war effort.

Perhaps the most important development in Edinburgh's industries in the Second World War was the construction of the Ferranti factory at Crewe Toll in 1943. It manufactured gyro gun sights for Spitfires. At the end of the conflict, Ferranti established an electronics research laboratory that laid the foundations for the growth of high-tech industries in Edinburgh. By the 1960s, when it manufactured radar and missile guidance systems, Ferranti had become Edinburgh's biggest employer, with a workforce of over 6,000 people, of whom around 500 were women. Close by, Bruce Peebles and Co. employed 1,700 in their works at East Pilton and continued to make generators and high-voltage power transformers.

Before the Second World War, there were six firms in Edinburgh making gas meters in the city, employing 800 people. By the early 1960s only three were left, employing 300, of whom two-thirds were with United Gas Industries. Bonnington Castings Ltd possessed the only steel foundry in Edinburgh at this time. It produced castings for the oil industry and for rolling stock. At this time it was one of the most highly mechanised light metal casting plants in the country.

Chilled iron goods were produced by Miller & Co. Ltd. Their surfaces were much harder than iron produced by normal castings. Chilled iron rolls were used in the processing of paper, sheets and towels. The Canadian firm Nuclear Enterprises established a branch in Edinburgh in 1955 to manufacture scientific instruments to measure radiation. By this time there were over 20,000 people employed in engineering in Edinburgh. There were around 100 enterprises with more than twenty people. Unfortunately, by the end of the twentieth century many would be no more.

In the decades following the Second World War, the traditional industries, such as brewing and publishing, continued to be a major source of employment. During the Second World War, there was not a great fall off in beer production like in the First World War, as it was regarded as vital for maintaining the morale of the troops. In the years immediately after the conflict, some 4,500 people were employed in this industry. As late as 1965, there were twenty breweries in Edinburgh but within just over a decade the number had dropped to just six. Many well-known names were lost through a series of takeovers in the post-war years; for instance, William Younger amalgamated with McEwans to form Scottish Brewers. Despite these changes, the production of beer increased. Investment in the remaining breweries enabled expansion, most notably the construction of a large new brewery at Fountainbridge. When it opened in 1973, it was one of the largest automated breweries in the world.

In the mid-twentieth century, much of Edinburgh's food and drink was still locally produced. There were more than seventy home bakeries producing pies, cakes and rolls plus a number of larger enterprises. In 1963, some 2,200 persons were employed in city bakeries, of which 1,500 were men. A further 2,600 workers, of whom almost 1,800 were women, were employed in the manufacture of confectionery.

The manufacture of rubber goods in 1951 employed no less than 4,400 workers, with around 75 per cent of them at North British Rubber Co.'s mill at Fountainbridge. At this time it was the largest employer in the city, producing everything from car tyres to golf balls and hot-water bottles.

Of the fifty to sixty British carton manufacturers, no less than eight were located in Edinburgh in the early 1960s. In contrast to this relatively new industry, there were two mills still manufacturing snuff around this time.

Throughout the twentieth century, Edinburgh's financial sector prospered and it remained a vital part of the city's economy. By the 1950s, Standard Life was the largest life assurance company in Scotland. At the end of that decade, the Bank of Scotland installed their first computer. This bank along with three others – the Royal Bank of Scotland, the National Commercial and British

Linen – had their headquarters in the city. In the 1960s, there were around 700 chartered accountants in Edinburgh. The actuarial profession also had their headquarters here.

In 1920, the foundation stone was laid for the construction of University of Edinburgh King's Buildings on the southern edge of the city. This was a move somewhat ahead of its time. In the closing decades of the twentieth century, there was a large-scale migration of both academic and economic activity away from the city centre to its outer edges. Heriot Watt University moved to a new campus at Riccarton. Edinburgh's oldest school, the Royal High, moved to more spacious accommodation at Barton in the late 1960s.

Retailing began to undergo a major transformation as well. The St James Centre, which opened in 1970, was the first shopping mall in Edinburgh. This was in the centre of the city but with an increase in car ownership, out-of-town shopping centres also became popular. In the 1980s, Asda and Comet stores were built near Portobello. Cameron Toll, on the south side of the city, opened in the early 1980s. This was followed by the much larger Gyle shopping centre on the western edge and Kinnaird Park on the eastern edge. At the same time, well-known department stores in the centre of Edinburgh such as Binns, Darlings and R. W. Forsyth began to disappear. In 1986, there were some 3,527 retail shops in the city, although they too were threatened by the rise of the out-of-town shopping centres.

Sighthill Industrial Estate was set up to encourage industry to establish on the western edge of Edinburgh where there was plenty of room for expansion. Golden Wonder Crisps were made here from 1947, and had become the leading brand of crisps in Scotland by the early 1960s. Economic incentives in the form of government grants were introduced to attract companies to areas of high unemployment and away from Edinburgh altogether. Long-established industries began to drift away. Others were forced out of business due to competition, particularly from the Far East. In 1983, the long tradition of shipbuilding at Leith came to an end with the closure of the Robb Caledon yard.

The highly sought-after Edinburgh crystal was made near Abbeyhill in the early twentieth century, but in 1969 manufacture moved to a new plant in Midlothian. One of Edinburgh's oldest companies, James Ritchie & Son clock manufacturers, moved out of the city to Livingston in the closing years of the twentieth century. Bank Paper Mill at Balerno employed 500 people turning out high-quality paper but it had closed by the end of the twentieth century, along with many of the other long-established industries located along the Water of Leith. Scottish Agriculture Industries opened a large fertiliser plant at Leith in the mid-1950s. It had a workforce of over 300 people, but it closed in 1991. The discovery of offshore oil in the North Sea provided an alternative source of jobs at Leith Docks when it became a major base for fabricating undersea pipelines.

Desktop publishing and foreign competition led to the demise of Edinburgh's once thriving publishing industry. Typesetters were no longer required for many publications. Between 1963 and 1981, the workforce in the printing and publishing industry declined from 11,100 to 6,300. The well-known map publisher, Bartholomew, was acquired by Harper Collins and its highly skilled workforce moved out of their Newington premises to Bishopbriggs, near Glasgow.

At the census of 1991 just under 31,000 people were employed in industry. Around ten years earlier, the industrial workforce had been 42,349 representing a reduction of around a quarter in the decade. Out of a total workforce of around 226,000 in 1991, 7,519 were in electrical and electronic engineering, 8,347 in food and drink, 4,259 in printing and publishing and no less than 10,853 in construction. The fifteen largest companies with their head office in the city ranked by their turnover in 1992 were

1. Standard Life
2. Royal Bank of Scotland
3. Scottish Widows Life Assurance
4. Bank of Scotland
5. Scottish and Newcastle
6. Scottish Equitable
7. John Menzies Retailing
8. United Distillers
9. Scottish Provident Life Assurance
10. Scottish Life Assurance.
11. Christian Salvesen Distribution
12. Dawson International Textiles.
13. TSB Banking Scotland
14. Miller Group Construction
15. Kwik Fit Vehicle Maintenance.

Rapid changes taking place in the economy would transform the situation within the next couple of decades. Dawson International Textiles would suffer financial trouble and move from its prestigious quarters in Charlotte Square to the Scottish Borders. Scottish Provident and Scottish Life were taken over by Royal London in the early years of the twenty-first century and today trade under that name. Scottish and Newcastle (Brewing) was sold to Heineken in 2008 and United Distillers was absorbed into the Diageo Group a few years earlier. Christian Salvesen was the largest private company in Scotland in 1987, but twenty years later it was merged with a French haulage company.

In 1994, the following companies were listed as the largest manufacturers in Edinburgh:

1. GEC Marconi Avionics Defence related electronics.
2. Uniroyal Englebert Tyres
3. Scottish and Newcastle Brewing and Leisure
4. Burtons Biscuits Food
5. D. B. Marshall Food
6. Scotsman Publications Publishing
7. Hewlett Packard Electronics
8. Racal-MESL Electronics
9. Ethicon Pharmaceuticals
10. William Thyne Packaging

Just over a decade later, only three of the above companies – Burtons Biscuits, GEC Marconi Avionics and Scotsman Publications – were still operating in Edinburgh. Consolidation within the manufacturing sector and increasing competition due to globalisation led to the closure of many of Edinburgh's remaining factories. The Uniroyal Tyre plant at Ratho passed into the ownership of Continental tyres, who closed it in 1999 with the loss 800 jobs.

D. B. Marshall, that raised and processed poultry near Edinburgh Airport, once employed 1,700 but went out of business in 1996. The reduction of jobs in the manufacturing industry was somewhat compensated by the growth in the number of tourists visiting Edinburgh. At the end of the twentieth century tourism generated an estimated 20,000 jobs, with some 12,400 in the hotel and catering trade. New hotels began to appear to cater to this market, although for most of the twentieth century no new examples had been built. Among the first was the Sheraton Hotel in Lothian Road, built in 1984.

The Madelvic Car Factory at Granton is the oldest surviving car factory building in Britain. It was here that the Madelvic Co. manufactured electrically powered cars, which looked more like old coaches. The company unfortunately went bankrupt in 1900 and the building was taken over by a succession of vehicle manufacturing firms whose success was equally short-lived.

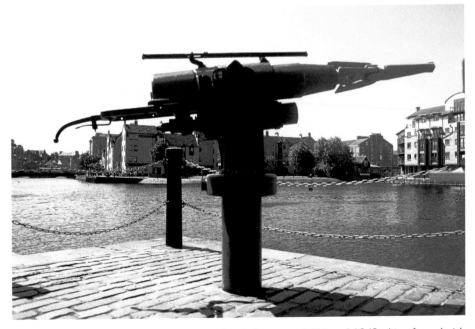

A preserved harpoon gun on the Shore, Leith. Between 1616 and 1842, ships from Leith hunted whales in the waters off Greenland. In 1908, Christian Salvesen began dispatching ships to the Antarctic. Five years later, its whaling fleet was the largest in the world.

# James Dunbar's PRIZE MEDAL Aerated Waters

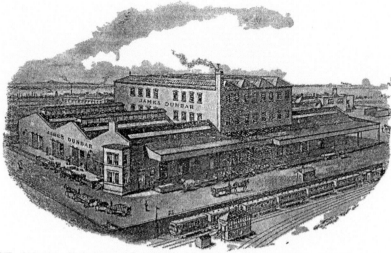

**ALBION ROAD FACTORY**

'PHONE **5 2 1 3** CENTRAL

## THE MOST UP-TO-DATE AERATED WATER FACTORY IN GREAT BRITAIN

## THE COMMERCIAL BANK OF SCOTLAND LIMITED

BRANCHES THROUGHOUT SCOTLAND including all the ...principal Ports...

HEAD OFFICE: **14 George Street, Edinburgh** *General Manager*—JOHN M. ERSKINE

Glasgow Chief Office: **113 BUCHANAN STREET**

London City Office: **62 LOMBARD STREET, E.C.3**

Every Description of British Banking and Foreign Exchange business .......transacted......

LOCAL BRANCHES:

LEITH - - - - - 60 Constitution St.
BONNINGTON - - - 131 Newhaven Rd.
GREAT JUNCTION STREET No. 145
LOCHEND and RESTALRIG 3 Vanburgh Place

*Above:* An advertisement for James Dunbar's aerated waters in 1921. This company was one of several that made ginger beer and other soft drinks in Edinburgh.

*Left:* A 1937 advertisement for the Commercial Bank of Scotland, which had its head office in Edinburgh. Three years later it had 385 branches in Scotland – more than any other bank. In 1958, it merged with the National Bank of Scotland.

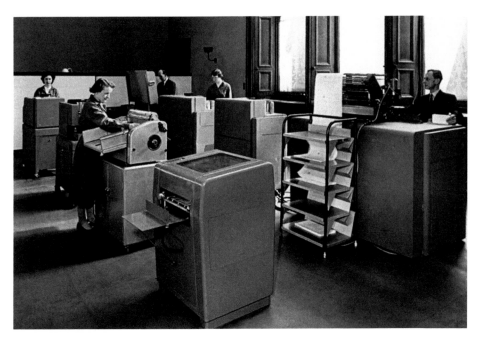

Bank of Scotland centralised accounting unit in George Street, Edinburgh, in the late 1950s. (Courtesy of Lloyds Banking Group plc archives)

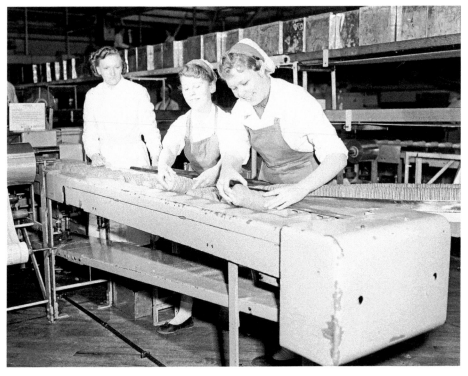

Employees of McVitie and Price Ltd pick out rows of biscuits for packing at the Gorgie cake and biscuit factory in 1954. (© Scotsman Publications Ltd/Licensor Scran)

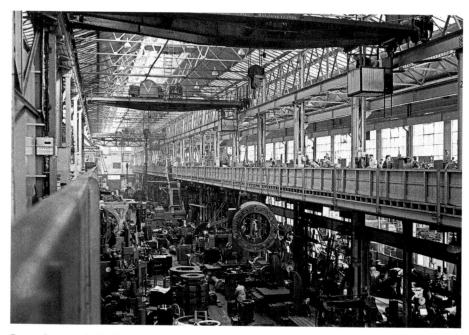

Bruce Peebles & Co. Ltd engineering works at East Pilton in 1951. The company produced large generators and transmission transformers for the power industry. (© Scotsman Publications Ltd/Licensor Scran)

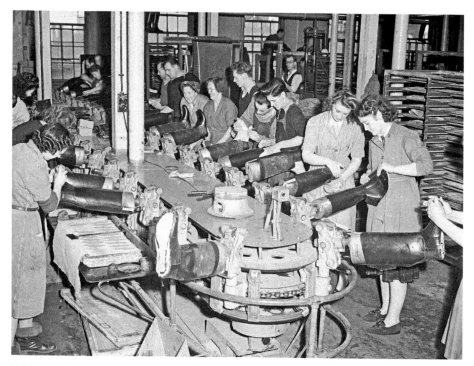

Wellington boots being made at the North British Rubber Co. factory at Fountainbridge in 1953, the birthplace of this type of footwear. (© Scotsman Publications Ltd/Licensor Scran)

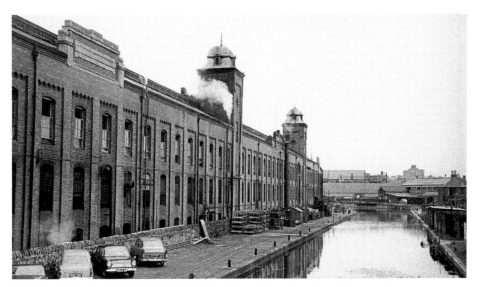

The North British Rubber Co. Works (Castle Mills) located next to the Union Canal at Fountainbridge in 1966. At that time, it was the largest manufacturing company in the east of Scotland. (© Royal Commission on the Ancient and Historical Monuments of Scotland SC677855/Licensor Scran)

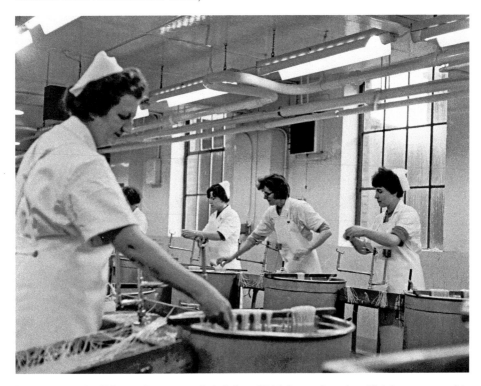

Workers at the Ethicon factory at Sighthill in 1965. It produced artificial catgut used in surgical procedures, which that was invented by Edinburgh pharmacist George Merson. (© Scotsman Publications Ltd/Licensor Scran)

Cattle for sale at Gorgie livestock market in 1969. It closed in 2002 bringing hundreds of years of tradition to an end as it was Edinburgh's last livestock market. (© Scotsman Publications Ltd/Licensor Scran)

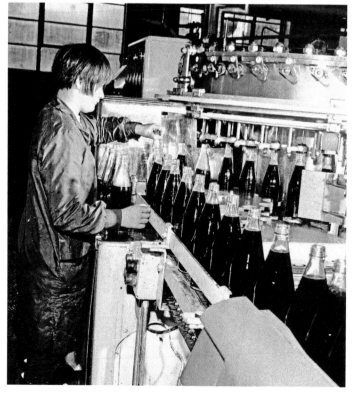

A woman working at Henry's soft drink bottling plant in Lower London Road in 1970. (© Scotsman Publications Ltd/Licensor Scran)

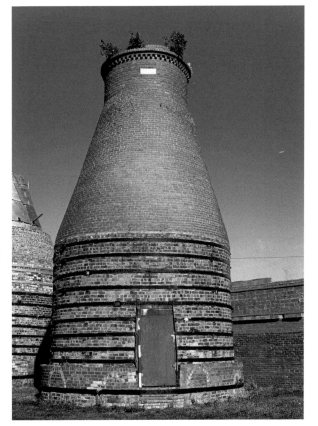

*Right*: Portobello was once a thriving industrial centre. Two pottery kilns have been preserved from Buchan's Pipe Street works, which closed in 1972.

*Below*: A Christian Salvesen lorry in the late 1970s. The company, which built its fortunes on whaling, became a major European transport and logistics company in the latter part of the twentieth century.

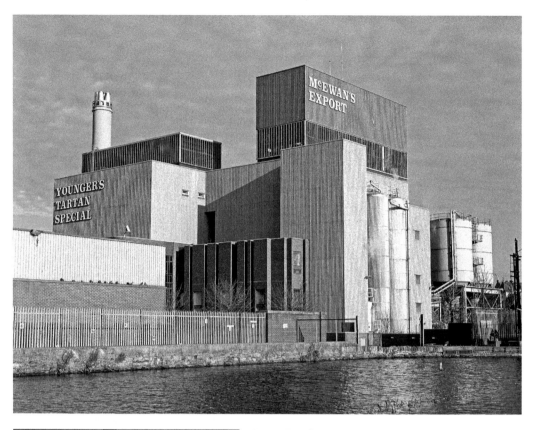

*Above:* The Scottish and Newcastle Brewery at Fountainbridge in the closing years of the twentieth century. It had a workforce of around 400. William McEwan first opened a brewery in the vicinity because of its spring waters, which give the area its name. This modern example of a brewery closed in 2004 and has since been demolished.

*Left:* Grant's department store on the Bridges in the 1970s. There were once numerous department stores in the centre of Edinburgh but most had closed by the end of the twentieth century.

B&Q and Comet stores at the Jewel, which opened in the mid-1980s, were early examples of retail units located on the periphery of Edinburgh.

Scottish Agriculture Industries fertiliser plant at Leith Docks. In the early 1980s it employed around 340 persons. A decade or so later, it had ceased operation.

The impressive offices of *The Scotsman* and *Edinburgh Evening News* pictured in the late 1980s. The papers were printed in the lower part of the building. Since then the newspapers have decamped to smaller premises.

The Sheraton Hotel in the heart of Edinburgh, next to Lothian Road. It was constructed in 1984 and heralded a new era in hotel building in the city.

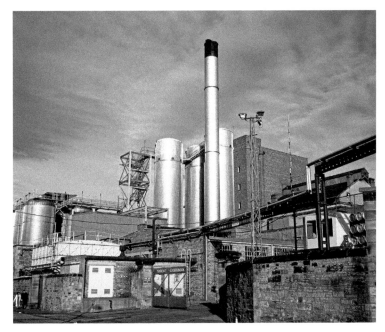

The Tennent Caledonian Brewery at Roseburn in the mid-1980s. Around a decade later it had closed and as with many other former industrial sites, housing now occupies the area.

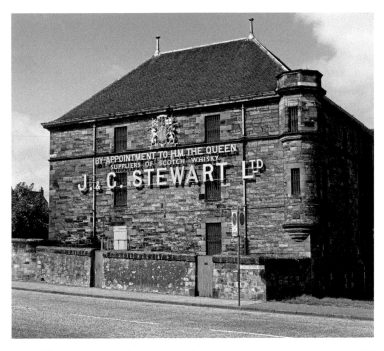

Edinburgh, and Leith in particular, once had numerous bonded warehouses. This example at St Leonard's belonged to J. & G. Stewart, which made the famous cream of barley whisky. Like many other bonded warehouses in the city, it had fallen into disuse by the end of the twentieth century and has been converted into flats.

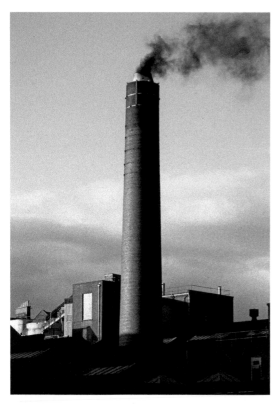

A chimney for the Holyrood Brewery belches smoke shortly before its closure in 1986. At that time it was owned by Scottish and Newcastle Breweries, although it was originally established by William Younger.

Filling tins of paint by hand at the premises of Craig and Rose in 1992. The company was founded in 1829 and opened a large paint manufacturing plant in Leith in 1874. In 2017, the company is still in business producing a wide range of paints, but like many manufacturing businesses it has moved away from Edinburgh to Dunfermline. (Peter Stubbs, www. edinphoto.org. uk)

West Office Park at the Gyle, pictured not long after its completion in 1986. Its construction heralded the move of several financial companies out of the centre of Edinburgh to its western edge.

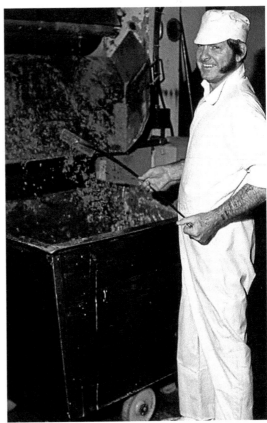

A worker at Duncan's Chocolate Factory in Beaverhall Road in 1991. Not long after, the company moved its premises to Lanarkshire. Its factory in Edinburgh has since been demolished and replaced by houses. (© Peter Stubbs, www.edinphoto.org.uk)

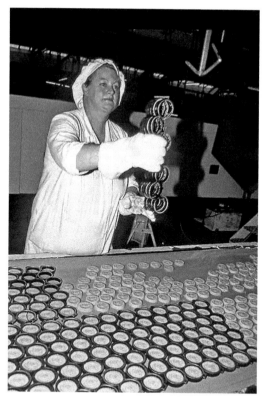

*Left:* Shortbread biscuits being made at the Burton's biscuit factory at Sighthill in 1991. Unlike many other biscuit and baking firms, the factory is still in operation in 2017. (© Peter Stubbs, www.edinphoto.org.uk)

*Below:* A wire-weaving loom at United Wire works at Granton in 1992. In 2017, this company became the largest manufacturer and supplier of woven wire cloth in Britain, having been in business for 175 years. (© Peter Stubbs, www.edinphoto.org.uk)

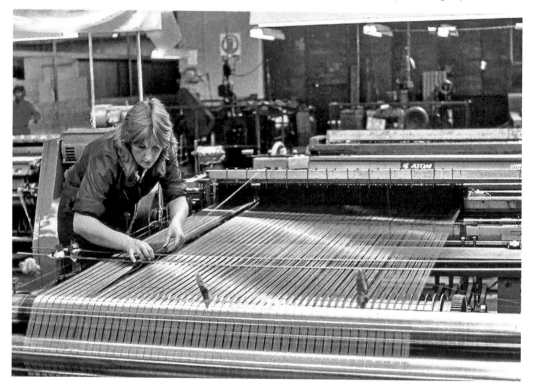

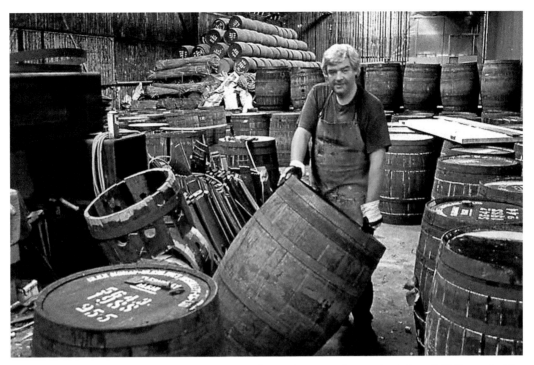

Anderson's cooperage at Leith Docks in 1992. A few years later it had closed. (© Peter Stubbs, www.edinphoto.org.uk)

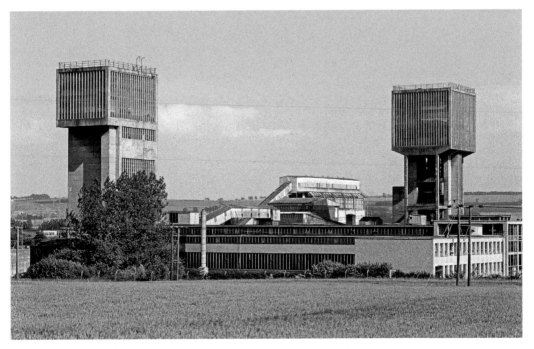

Monktonhall Colliery pictured shortly before its closure in 1997. It was situated near the south-eastern edge of Edinburgh and was the last deep mine in the Lothians.

The Gyle Shopping Centre on the west side of Edinburgh depicted shortly after it opened in 1993. Such developments have, up to a point, turned Edinburgh inside out, with much of the economic activity being conducted on its periphery instead of at its centre.

The Apex House, a large office block constructed in the late twentieth century close to Haymarket station.

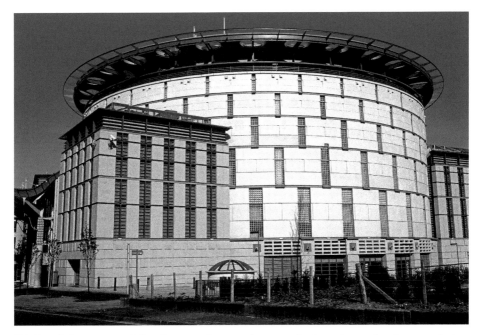

Edinburgh International Conference Centre photographed not long after its completion in 1995. It caters to around 200,000 delegates each year and generates around £60 million in revenue for Edinburgh.

Edinburgh's new financial district at the end of the twentieth century. It was constructed on the site of Princes Street station and railway sidings.

# THE TWENTY-FIRST CENTURY

In the early years of the twenty-first century, Edinburgh's manufacturing base continued to dwindle. Only one in twenty of its workers was employed in this sector by this time. The printing industry – one of the city's major employers a century earlier – had all but vanished, along with paper manufacturing in the Edinburgh area. On a more positive note, the city is still home to several independent publishers, among the best known being Canongate. Famous authors including, J. K. Rowling and Ian Rankin, continued to uphold the city's reputation as a source of popular literature.

The once equally important brewing industry clings on in 2017 with just the Caledonian brewery still functioning. The large Scottish and Newcastle complex at Fountainbridge closed in 2004 and moved production to England, where costs were lower. It was the largest remaining industrial site in the heart of Edinburgh. The biscuit and confectionery industry has also shrunk drastically, with the production of biscuits being confined to Burtons at Sighthill and shortbread by Nairns at Craigmillar. Even the electronics and computer sector has experienced a contraction in recent years. The massive Hewlett Packard factory at South Queensferry (founded in 1965) has closed and its site developed for housing. The former Ferranti works, now owned by the Italian company Leonardo, continues to employ around 2,000 people in 2017, producing advanced electronic equipment for the Eurofighter aircraft.

Edinburgh's long association with the medical industry suffered a serious blow in 2003 when Ethicon's factory at Sighthill closed with the loss of 800 jobs. It had manufactured surgical needles and stitching materials. At the end of the Napoleonic Wars, J. F. MacFarlan opened his first apothecary's shop in the High Street. Around a decade later the brothers Henry and Thomas Smith opened a similar premises, laying the foundations of modern pharmacology. The latter brother experimented with cannabis resin and produced the first scientific paper on the properties of marijuana. Both companies began to make morphine on a large scale. In 1847, Professor James Young Simpson and his associates discovered the anaesthetic properties of chloroform. At the professor's request, Thomas Smith's company soon began to produce what was one of the first totally synthetic drugs. During the First World War the MacFarlan Co. produced 1,477 miles of gauze, over 200 tons of lint and 7.6 million bandages. Its factory came under attack by German bombers in the Second World War, as it manufactured essential supplies of chloroform and morphine, but the bombs missed their target. The company amalgamated in 1960 with that founded by the Smith

brothers. By the early twenty-first century its works at Gorgie had become the largest manufacturer of opiate alkaloids in the world, permission having been given for it to grow poppies legally in British fields to produce morphine. The company has one of the world's widest range of pain relief products. MacFarlan Smith Ltd (now part of the Johnson Matthey Group) has also pioneered a drug (galantamine), manufactured from daffodil bulbs, to treat Alzheimer's Disease.

Despite the contraction of the manufacturing sector, Edinburgh's economy continues to go from strength to strength. The growth of the tourist industry and associated services has more than compensated for the loss of jobs in other sectors, with some 30,000 jobs depending on it. Around 3.85 million visitors came to the city in 2015, generating £1.32 billion for the local economy. After London, it was the second choice for foreign visitors as a destination in Britain. The main attractions are the castle, the Old Town and festivals. In the decades immediately after the Second World War, the tourist season was restricted to two or three months in summer. Now it lasts all year round. The International Festival held in August is the largest international arts festival in the world but is just one of several organised throughout the year. The Hogmanay Festival draws tourists to Edinburgh in the depths of winter and for the more academically minded there is now a Science Festival.

Business conferences have long been attracted to the city. To capitalise on this trade, a purpose-built conference centre was opened in Morrison Street in 1995 and now caters to around 200,000 delegates a year. There were sixty-seven meetings of international associations in Edinburgh in 2015 with business tourism contributing in excess of £300 million a year to the city's economy. Other high-profile venues, including the Botanic Gardens and City Chambers, are also used to host corporate events.

Many of the visitors to Edinburgh arrive via its airport. In 2016, it was served by over thirty airlines flying to around 130 destinations with an average of 333 flights per day. London was the busiest route with some fifty flights a day, followed by Bristol. The main foreign destinations were Amsterdam, Dublin and Paris. The facility employs around 5,000 people with around 660 directly engaged by Edinburgh Airport Ltd. Open twenty-four hours a day, it handled 12.4 million passengers in 2016, making it the busiest airport in Scotland and the sixth busiest in Britain. Surface communications are equally important, with Waverley railway station at the heart of the city being the terminus for the East Coast line from London. Other routes converge on it from Glasgow and Fife. By 2016 it was handling around 22 million passengers a year, nearly double that of ten years earlier. It is the second busiest station in Scotland after Glasgow Central. High-speed trains are maintained at Craigentinny Traction Depot at Portobello, the biggest of its type in Scotland. Locomotives are serviced and overhauled twenty-four hours a day. It is operated by Virgin East Coast, although other company's locomotives are overhauled here as well. On the other side of the city, Scotrail has a rail depot at Haymarket.

Until the middle of the twentieth century Leith Docks was served by an extensive network of coastal passenger services, which even included London despite the competition from railways. These have long since vanished. Much of its traditional cargo trade has dwindled away or been attracted to other ports. The closure of Cockenzie and Longannet power stations dealt a death knell to its trade in coal, but it is still used in 2017 as a base for specialist offshore vessels providing support for the North Sea oil and gas fields. The port is now a major destination for passenger cruise ships with around thirty vessels calling here each year. Some of the ships are now too large to enter the lock gates and so anchor off Newhaven or South Queensferry.

Most visitors prefer a longer stay than the brief visits offered on a cruise. In 2016, Edinburgh had around 150 hotels with 12,000 rooms available throughout the year. 'Top of the range' examples include the Balmoral, Hilton, Roxburghe, Sheraton and Caledonian. To cater for the booming tourist industry, new hotels have been opened on a regular basis. With limited room for new structures in the city centre, former banks and government offices have been given a new lease of life as hotels. Visitors to Edinburgh have a choice of a wide range of cuisine. The city has more than 500 restaurants in addition to cafés. They serve food from all corners of the world ranging from Argentina to Thailand. Although Edinburgh's brewing industry has almost been consigned to history, in 2016 there were 1,147 premises licenced to sell alcohol, of which 700 were pubs. This is the greatest concentration of drinking establishments per square mile for any city in Europe.

Many American and European cities have groups of high-rise offices that flaunt their prosperity from a distance. Edinburgh has no equivalent but this is deceptive. Its banking and financial services, which date back several centuries, had by the early twenty-first century grown to become next in importance to London. It is now the sixth largest investment management centre in Europe and the fifteenth largest in the world. Some 35,000 people were employed in the financial services sector in 2016. No less than 265 companies, including banks, insurance and investment companies, had offices in Edinburgh. Furthermore, more than 90 per cent of all Scottish fund managers are based in Edinburgh.

The Royal Bank of Scotland in 2002 was the second largest bank in Europe and had aspirations to become the world's largest. This ambition was dealt a blow with the financial crisis of 2007/8. The bank now concentrates on the British market, but in 2017 is still the tenth largest bank in Europe ranked by assets. For most of its history its headquarters was in St Andrew Square, but in 2005 it relocated to a sprawling 100-acre site at Gogarburn, close to Edinburgh Airport. Close by is Edinburgh Park at the Gyle, the largest business park in Scotland. It opened in 1995 and twenty-five years later is home to many leading financial institutions. Scottish Equitable was one of the first companies to move there. The company is now known as Aegon UK and employs 2,000 people at the site. Next to it are the offices of Kaimes Capital, which manages £44.5 billion on behalf of British and international investment concerns. Sainsbury Bank is another major financial company to have offices at Edinburgh Park, as does J. P. Morgan, one of the largest banking institutions in the USA. Tesco Bank also has its headquarters on the western edge of Edinburgh.

Many other major financial companies still have their offices in the heart of Edinburgh. Virgin Money acquired offices for its headquarters at St Andrew Square in 2011. Other important investment companies can be found at the west end of the New Town, particularly in the Georgian buildings of Melville Street. Not all the offices in the centre of the city date from this period. At the end of the twentieth century, a modern financial district was constructed on old railway sidings next to Lothian Road. It extends south to Fountainbridge and the old canal basin. Standard Life, one of Edinburgh's largest employers with a workforce of over 5,000 in 2013–14, moved its headquarters from George Street to a large modern office next to Lothian Road. The Lloyds Banking Group, which includes Scottish Widows and the Bank of Scotland, has two offices in the new financial district. It employed 7,500 people in Edinburgh in 2014. Other financial companies of note that have their headquarters in Edinburgh include Baillie Gifford, Martin Currie and Artemis Investment Management. New start-ups in 2017 included the UK Green Investment Bank. Multinational companies in Edinburgh, which process billions of pounds worth of transactions every day, include

State Street, HSBC, Scotie Generale, Bank of New York Mellon, Triodos, Franklin Templeton Investment, Blackrock, and First State Investments.

Digital technology now plays a vital role in financial transactions. Edinburgh has gained a reputation as a driving force in the evolution of the Fintech sector, which includes e-commerce and mobile banking. By 2017 Edinburgh had over 25,000 people working within the digital sector and the number of software companies numbered over 100 – one of the highest concentrations anywhere in Britain. Several companies have departments to carry out research and development in this field. Founded in Edinburgh in 1988, Axios Systems produces software for asset management. Another local start-up, Craneware, supplies US hospitals with software for financial management. The high-tech companies also produce software for numerous other uses outside the financial sector. These include the travel website Skyscanner, which was created in Edinburgh, although it was bought by China's leading travel company in 2016. The US fantasy sports provider Fandue, headquartered in New York, have their development office in Edinburgh. Amazon's oldest development centre outside the USA is in Edinburgh and is responsible for devising, creating and growing mainframes and websites for Amazon worldwide. Behind the city's success in attracting high technology companies is Edinburgh University School of Informatics, which is the largest in Britain. It has produced cutting edge research in the field of computer science and its highly skilled graduates have gone on to work in many of the software companies.

Edinburgh's overall reputation as a place of learning has also continued to grow. A hundred years ago, there was only one university. The number had increased to four by 2017 – University of Edinburgh, Heriot Watt University, Napier University and Queen Margaret University. There is also Edinburgh College, which offers courses in higher education. The 82,000 university and college students provide a major stimulus for the city's economy with their demand for accommodation and services. The University of Edinburgh had 36, 500 students in 2016/17 icluding 11,000 from overseas, representing two-thirds of the countries of the world. In 2014, the university was the third largest employer in Edinburgh, its 13,000 staff ranging from professors to caretakers. Heriot Watt University had around 8,000 students at its Riccarton Campus with further campuses in the Orkneys, Scottish Borders and overseas. Edinburgh Napier University has no less than three campuses – Craiglockhart, Merchiston and Sighthill – with 18,000 students, including 5,000 from over 100 countries. Queen Margaret University near Musselburgh has the first purpose-built campus in Scotland in forty years.

The largest employer in Edinburgh in 2013–14 was the NHS Lothian with a workforce of almost 20,000. Over the last few decades, the number of hospitals has been drastically reduced; medical treatment is now centred on the new Royal Infirmary and the Western General. The former is much more than just a hospital for treating the sick. Edinburgh University has a considerable presence there with a medical teaching school attached. There is also the Queens Medical Research Institute and the Scottish Centre for Regenerative Medicine. Around 5,000 people, including 1,200 researchers, work in what is known as Edinburgh's Bioquarter, which opened in 2012. Many of the remainder work in the Royal Infirmary. The mission of the Bioquarter is to encourage medical research and develop new medicines and diagnostic instruments. Research into life sciences for both humans and animals is not just confined to the Bioquarter but is also undertaken at the six other science parks in the vicinity of Edinburgh, including Roslin Biocentre.

Edinburgh itself is home to the Royal College of Surgeons, founded over 500 years ago, and is now one of the oldest professional institutions in the world. In the past the academic world tended to be disconnected with that of business and commercial companies but in

recent decades there has been a dramatic change in that situation. Heriot Watt University set up a research park in its grounds in 1971. It was the first of its kind in Europe and by 2017 it was the largest. A wide range of activities from precision engineering to life sciences take place here. Among its tenants are the Institute of Occupation Medicine, the Scottish Whisky Research Institute and TES Electronic Solutions. Heriot Watt University Research Park falls within the Edinburgh Science Triangle. This extends from Livingston in West Lothian to Musselburgh in East Lothian and has its southern limit marked by Easter Bush Campus in Midlothian. Edinburgh University has been closely involved in the development of several high-tech companies, including Sensewhere Ltd, which started life as a spin-off from the university. The company has gone on to develop Wi-Fi and Bluetooth that can pinpoint a user's location in areas like shopping centres where GP systems do not function. It has more than 600 million active users monthly.

Edinburgh Designs is another innovative niche company that co-operates closely with Edinburgh University. It was founded in 1987 and has gone on to assist with the development of wave testing tanks for universities and governments across the world. The company also produces wave generators that can simulate deep ocean waves to test their effects on ships and other devices that can replicate coastal waves so their effect on the shoreline can be evaluated. Edinburgh Designs created the giant wave and flood scenes for 2012 film *The Impossible*, which starred Ewan McGregor.

Private equity has been responsible for establishing Codebase in former government offices in the west Port at the edge of the Old Town. Its function is to foster the growth of high technology companies by bringing together ambitious entrepreneurs, highly skilled workers and top investors. As a mark of its success, in 2017, its offices were home to more than a hundred of the country's leading technology companies. The Techcube, on the edge of The Meadows, is a similar enterprise intended to encourage new businesses.

Although Edinburgh's role as a centre of government suffered a blow with the abolition of Lothian Regional Council and the closure of its headquarters in George IV Bridge, it has been more than compensated by the return of a Scottish Parliament after a gap of nearly 300 years. Edinburgh then became a capital city in more than just name. In 2013–14 the Scottish government had about 4,000 staff. The number of civil service staff is likely to grow greatly as in 2017 there were plans to relocate 3,000 posts from Bathgate and Livingstone.

Local government is in the hands of the City of Edinburgh Council, which had 18,617 employees in 2014, the second largest employer after NHS Lothian. While many of its staff work at the City Chambers and the new office complex in Market Street, others are scattered across Edinburgh in schools, libraries, etc. In 2013–14, the Lothian and Borders Police, now Police Scotland, was the eighth largest employer in Edinburgh with 2,439 staff. The tenth largest employer was the Royal Mail with 2,257 staff.

Other departments associated with the apparatus of government have their head offices in Edinburgh, including the Forestry Commission and Historic Scotland. There is also the National Library of Scotland, which has a copy of every book published in Britain in recent centuries. The High Court of Justiciary (the supreme criminal court in Scotland) and the Court of Session (the supreme civil court of Scotland) – collectively known as the Supreme Courts of Scotland – are situated in the Old Town of Edinburgh. The Court of Session dates from 1532. The High Court of Justiciary was created in its present form in 1672. The authority of the Supreme Courts encompasses the whole of Scotland.

Appropriately, the only prison in south-east Scotland is in Edinburgh at Saughton. A short distance away at the Gyle in an area mainly occupied by financial companies is the headquarters

of the Scottish Prison Service. Numerous prestigious legal firms also have their offices in Edinburgh. Among them is Eversheds Sutherland, one of the world's largest international law firms. Like many other legal firms it is located on the western edge of the New Town close to many of the financial and investment companies.

To serve the needs of both government and private companies, Edinburgh is home to some of Scotland's largest marketing and advertising companies. They include the Leith Agency, public relations specialists Weber Shandwick and Tayburn Design, an award-winning creative branding and design agency.

In 2017, a study named Edinburgh the best city in the UK to launch a business. It ranked ahead of London, Bristol and Glasgow because of its 'speedy internet connections, reasonable office rent and a host of university graduates'. Further to this, the Swedish financial technology firm iZettle, which offers a range of financial products for small businesses including payments, point of sales, funding and partners applications, set up an office in the West Port in 2017. According to a survey carried out by this firm, Scotland was thought to be the best place to set up a new enterprise for five principle reasons, including the support offered by parents and partners. Those that replied also believed that having 'a warrior spirit' was a key trait to making small businesses thrive! iZettle remarked that, 'This may be the reason why all Scottish respondents say they don't regret starting a business and if they had the choice they would do it all over again.'

Construction cranes in the centre of Edinburgh at sunset. With a booming financial sector there is a constant demand for new offices.

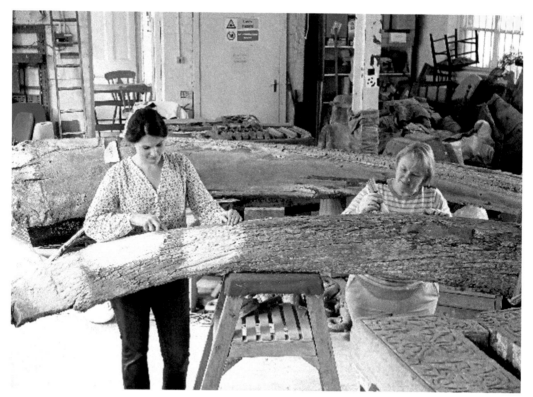

Conservators at the studios of Nicolas Boyes Stone Conservation Ltd at work on the Meadows whalebone arch in 2015. This is one Britain's leading conservation and restoration companies, specialising in carved stone and the fabric of historic buildings. (The City of Edinburgh Council)

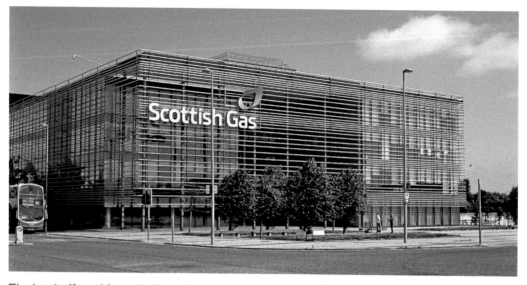

The head office of Scottish Gas, which in other parts of the UK is known as British Gas. It is built on the site of the former Granton gasworks.

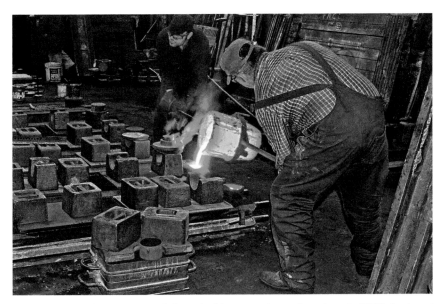

Casting railings at Charles Laing & Sons Ltd, brass and iron founders, in 2006. At that time the company was located in Beaverbank Place but has since moved out of Edinburgh to Fife. (© Peter Stubbs, www.edinphoto.org.uk)

A wreath of artificial poppies being created at the Lady Haig Poppy Factory at Warriston in 2015. It employs around forty ex-servicemen who produce over five million poppies each year for remembrance ceremonies across Britain. (© Peter Stubbs, www.edinphoto.org.uk)

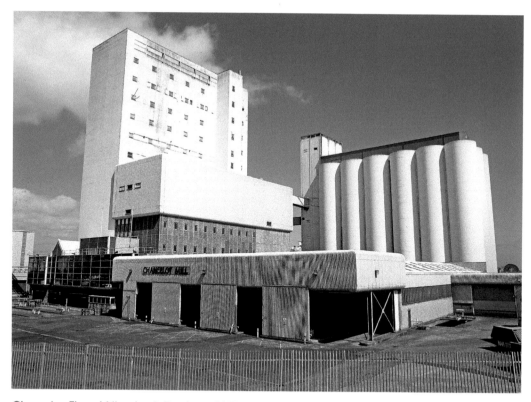

Chancelot Flour Mill at Leith Docks in 2017. It is operated by the American flour giant ADM and produces organic and non-organic flour for Scotland and the north of England.

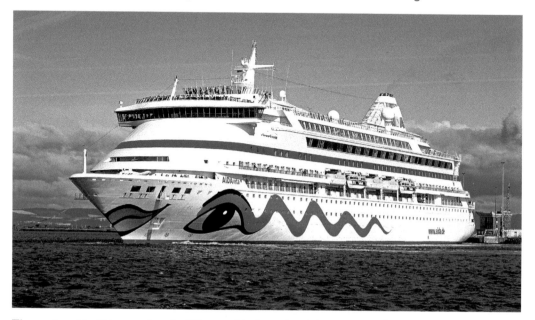

The cruise ship *Aida* entering the Western Harbour, Leith Docks. Visits by such vessels have become commonplace in summer months, doing much to boost Edinburgh's tourist trade.

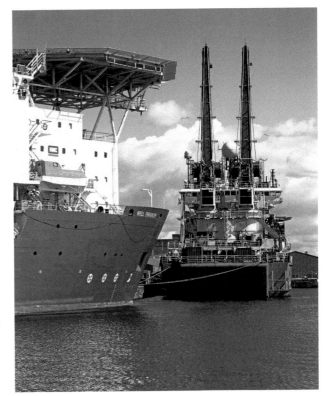

Offshore oil support vessels at Leith Docks in the early years of the twenty-first century. The discovery of oil in the North Sea provided a major boost for the port in the 1970s. Although production is now in decline, Leith Docks still remains an important base for offshore vessels in 2017.

An airliner operated by Easyjet approaching Edinburgh Airport from the east over one of the few remaining areas of farmland within the city's boundaries.

*Above:* At the end of the nineteenth century, Edinburgh was said to be in danger of becoming little more than a provincial city. With the restoration of the Scottish Parliament, it has become more than just a capital city in name.

*Left:* Edinburgh Airport's iconic air traffic control tower is nearly 200 feet tall and stands close to the terminal. It is responsible for handling around 120,000 aircraft movements a year at Scotland's busiest airport.

*Right:* The Crown Office and Procurator Fiscal in Chambers Street is responsible for the prosecution of criminals in Scotland. The city is home to the High Court of Justiciary and the Court of Session, collectively forming the Supreme Courts of Scotland.

*Below:* The new Royal Infirmary hospital situated at Little France on the southern edge of Edinburgh. It is part of Edinburgh's Bioquarter, which brings together the infirmary, life science companies, the world-famous University of Edinburgh's medical teaching school and many of its health and bioinformatics research institutes.

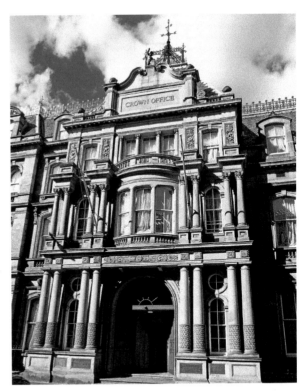

A member of University of Edinburgh's School of Informatics conducting an experiment in robotic movement. The department is a world leader in computer science research and teaching. (Marketing Edinburgh)

Queen Margaret University was constructed on a greenfield site near Musselburgh between 2007 and 2008.

The Granton Campus of Edinburgh College in 2017. It has two other campuses in Edinburgh, at Milton Road and Sighthill, as well as a further one at Dalkeith.

While most of Edinburgh's remaining factories are hidden away on industrial estates, the Leonardo Airborne and Space Systems plant stands next to a major road junction at Crewe Toll. The factory makes airborne radar, UAV systems flight controls and display systems.

The University of Edinburgh's Institute of Genetics and Molecular Medicine located at the Western General Hospital, one of two major hospitals in the city. Since the eighteenth century there has been a close relationship between the university and the city's hospitals.

Napier Technical College gained university status in 1992. It has three campuses in Edinburgh – at Craiglockhart, Merchiston and Sighthill. The latter is pictured here.

The west end of the New Town of Edinburgh was originally constructed as a residential development. In the twenty-first century many leading investment firms and legal companies are housed behind the original façades.

A branch of the TSB Bank in Hanover Street in 2017. The TSB Bank has its head office a short distance away in George Street.

The headquarters of Standard Life in Lothian Road, one of Edinburgh's major employers. In 1995, the company decided to consolidate its operations – previously scattered across the city in twenty offices – into this large building.

A Scotrail train approaching Haymarket station in 2017. Next to the station are modern office blocks, including one housing COSLA, the national association of Scottish local government councils.

The large number of restaurants and pubs in Edinburgh are one of its attractions for tourists. Le Di Vin wine bar and La P'tite Folie restaurant in Randolph Place, the New Town, are housed in this distinctive building.

The head office of Baillie Gifford Co. in Leith Street. Founded in 1908, this global investment company manages assets worth £173 billion in 2017.

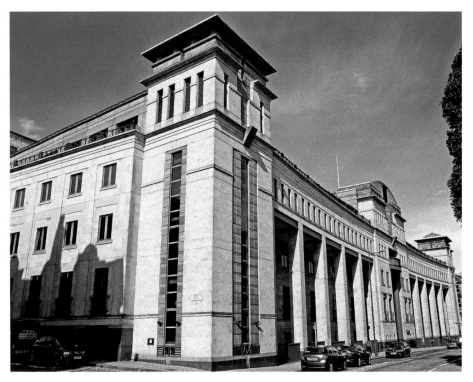

Saltire Court, a large office development facing Edinburgh Castle. In 2017, the complex housed several prestigious companies including the lawyers Shoosmiths, fund managers Martin Currie and accountancy firms Deliotte and KPMG.

A modern office in Edinburgh. Today, much of Edinburgh's workforce operates in such conditions. In the past the situation was very different, when work was mainly of a manual nature performed outdoors. (Marketing Edinburgh)

Exchange Crescent in the heart of Edinburgh's business and financial district. Developed in 2000, it consists of six stories of flexible high-quality office accommodation.

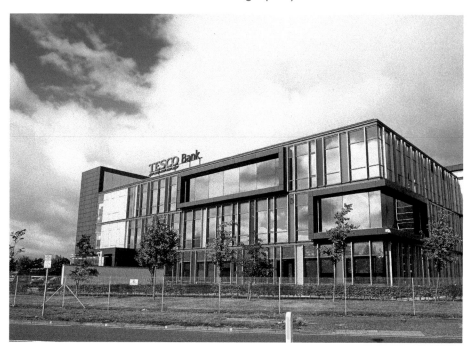

One of a new generation of banks to locate its headquarters in Edinburgh is the Tesco Bank. It was founded in 1997 and has its main office at the Gyle, close to numerous other financial firms.

A general view of Edinburgh Park located on the western edge of Edinburgh. It is Scotland's premier business park extending across 143 acres and home to many leading financial firms.

The offices of the American investment bank J. P. Morgan at Edinburgh Park. It is just one of several international financial companies to have a presence in Edinburgh.

*Right*: General view of Fort Kinnaird, located on the eastern edge of Edinburgh. It opened in 1989 and by 2017 had become the second largest retail park in Britain. It has over seventy retailers.

*Below*: The Ocean Terminal shopping centre at Leith Docks. It opened in 2001 and was constructed on the site of the Henry Robb shipbuilding yard.

*Left*: A shop at Haymarket devoted to the selling of bagpipes. Over the last century Edinburgh has had a small number of shops devoted to selling this distinctive musical instrument.

*Below*: Many small shops in the city centre cater for the tourist trade, such as this example in the Canongate.

The Usher Hall, which describes itself as 'Scotland's premier live music venue'. It owes its existence to the whisky distiller and blender Andrew Usher, who donated funds for its construction.

A constant reminder of the importance of tourism to Edinburgh are the fleets of sightseeing buses that traverse its streets. This strikingly painted example is setting off from Waverley Bridge with the Scott Monument visible in the background.

With several of the docks at Leith redundant in the late twentieth century, the site was selected for a large office block to house civil servants. Known as Victoria Quay, it is pictured here shortly after it opened in 1996. With devolution, the wording on the entrance 'Scottish Office' has been replaced with 'Scottish Government'. Both local and national government are major employers in Edinburgh.

The Techcube located in the former Royal Veterinary College building at the eastern edge of the Meadows. It is a private venture aimed at providing office space for start-up companies and small businesses.

# TOP EMPLOYMENT SECTORS IN THE CITY OF EDINBURGH 2011–2012 (FIGURES FROM EDINBURGH BY NUMBERS 2013/2014)

Human health and social work: 45,300
Wholesale, retail and repair: 36,400
Financial services: 34,600
Education: 29,200
Professional, scientific and technical activities: 27,100.
Accommodation and food services: 26,800
Public administration, defence and social security: 18,700
Information and communication: 12,400
Transportation and storage: 10,200
Arts, entertainment and recreation: 10,000
Construction: 9,000
Manufacturing: 7,300
Other service industries: 5,500
Real estate: 5,200
Primary industries and utilities: 3,200

# ACKNOWLEDGEMENTS

All photos are the author's own except where credited.

Peter Stubbs, Edinphoto, for allowing me to use some of his pictures from his Edinburgh at Work project.
Amanda Noble, Group Archivist and museum, Lloyds Banking plc.
Alison Stoddart, Capital Collections, the City of Edinburgh Council.
Ross Dimsey for editing the text.